JOHN B KEANE is one of Ireland's most humorous authors and is recognised as a major Irish playwright. He has written many bestsellers including *Letters of a Successful TD, Letters of an Irish Parish Priest, Letters of an Irish Publican, Letters of a Matchmaker, Letters of a Love-Hungry Farmer, The Gentle Art of Matchmaking, Irish Short Stories, More Irish Short Stories, The Bodhrán Makers* and *Man of the Triple Name.* His plays include *The Year of the Hiker, Big Maggie, Sive, Sharon's Grave, Many Young Men of Twenty, The Man from Clare, Moll, The Change in Mame Fadden, Values, The Crazy Wall* and *The Buds of Ballybunion.*

THE FIELD

JOHN B. KEANE

New Revised Text
edited by
Ben Barnes

THE MERCIER PRESS

THE MERCIER PRESS, 4 Bridge Street, Cork
24 Lower Abbey Street, Dublin.

© John B. Keane, 1991

ISBN 0 85342 976 6

The Field is a copyright play and may not be performed without a licence. Application for a licence for amateur performances must be made in advance to The Mercier Press, 4 Bridge Street, Cork. Professional terms may be had from Mr John B. Keane, 37 William Street, Listowel, Co. Kerry.

Printed in Ireland by Colour Books Ltd., Dublin

This edited two act version of *The Field* was first presented in the Abbey Theatre, Dublin on Monday 9 February 1987.

LEAMY FLANAGAN	Darragh Kelly
BIRD O'DONNELL	Dónall Farmer
MICK FLANAGAN	John Olohan
MRS BUTLER	Áine Ní Mhuirí
MAIMIE FLANAGAN	Catherine Byrne
BULL McCABE	Niall Tóibín
TADHG McCABE	Brendan Conroy
SERGEANT LEAHY	Niall O'Brien
WILLIAM DEE	Macdara Ó Fátharta
DANDY McCABE	Eamon Kelly
MRS McCABE	Maura O'Sullivan
FR MURPHY	Des Nealon
THE FLANAGAN CHILDREN	Aoife Conroy
	Neilí Conroy
	Ruaidhrí Conroy
	Tom Lawlor
	Kerry-Ellen Lawlor
VILLAGE GIRLS	Aisling Tóibín
	Siobhán Maguire
THE BISHOP'S VOICE	Des Cave

DIRECTOR Ben Barnes
DESIGNER Tim Reed
LIGHTING DESIGNER Rupert Murray
MUSIC Ronan Guilfoyle

The Field was first produced by Gemini Productions at the Olympia Theatre, Dublin on 1 November 1965.

ACT ONE

Scene 1

[Action takes place in the bar of a public-house in Carraigthomond, a small village in the south-west of Ireland.

LEAMY FLANAGAN is playing pitch and toss with his younger brothers and sisters. Enter the BIRD O'DONNELL]

Bird:	Give us a half of whiskey for God's sake, Leamy, to know would anything put a bit of heat in me. Leamy, do you hear me talking to you?
Leamy:	'Tis freezing!
Bird:	'Tis weather for snowmen and Eskimos. Where's your father? This place is getting more like Las Vegas with all the gambling going on.
Leamy:	He's gone down to O'Connor's for the paper . . . That'll be half-a-dollar.
Bird:	Take your time, will you? Why aren't ye all at school?
Leamy:	Still on our Easter holidays. How's trade?
Bird:	Same as always . . . lousy!

[Enter MICK FLANAGAN scattering the children]

Mick:	Go upstairs, your dinner is ready. *[To LEAMY]* I thought I told you to sweep out the shop!
Leamy:	It's nearly finished.
Mick:	You've been long enough about it. Right Nellie, up to Muddy. Good morning, Bird.
Bird:	Good morning, Mick.
Mick:	Did you clean out the store?
Leamy:	I've done the half of it.
Mick:	The half of it! — I told you to do the whole of it.
Leamy:	I had to look after the kids while my mother was feeding the baby.

Mick: 'Tis too fond you are of hanging about with women and children. 'Tis a daughter you should have been not a son. *[Discovering another child]* And what are you doing hiding under the table, you little divil? *[To LEAMY]* Go and ask your mother will the dinner be ready soon.

Leamy: Yes, Da.

Mick: And finish off that store or you'll hear all about it from me.

Leamy: Yes, Da.

[Exit LEAMY, BIRD whistles]

Mick: In the name of goodness, will you cut out that bloody whistling! One would swear you were a canary.

[The Whistler, whose name is 'BIRD' O'DONNELL, looks at MICK in surprise]

Bird: *[Throwing rings at a ring-board]* I thought you liked whistling?

Mick: Whistling, yes. I like whistling. But that bloody noise you're making isn't whistling.

[Laughter from girls. BIRD comes to the counter. He has thrown two rings and leaves the other four on the counter]

Mick: C'mon girls, upstairs.

Bird: Give me another half-one. It might improve my pipes.

Mick: Have you the price of it?

[BIRD draws some change from his pocket and places it on the counter]

Mick: *[Counts money first, fills whiskey]* Who did you take down now?

Bird: Take down! That's illegal, that is! I could get you put in jail for that. A pity I hadn't a witness. 'Twould pay me better than calf-buying.

[MICK places whiskey on counter and takes price of it which he deposits in cash register. BIRD scoops up the rest of the money]

Mick:	There must be great money in calf-buying.
Bird:	Not as much as there is in auctioneering.
Mick:	*[Goes to the stove, to poke and put fuel in it]* Very funny! Very funny! Don't forget I have to use my head all the time.
Bird:	*[Leftish along counter]* Not half as much as I do. Did you ever try to take down a small farmer?
	[BIRD sits in angle of bar watching what is going on. Enter a small dumpy woman wearing a black-coloured coat. She is piled with parcels. She is MAGGIE BUTLER, a widow]
Bird:	Good morning, ma'am.
Mick:	Good morning, ma'am. Ah! Is it Mrs Butler? I didn't see you with a dog's age.
Maggie:	Good morning to you, Mr Flanagan. I'm afraid I don't be in the village very often.
Mick:	What will I get for you?
Maggie:	*[Laughs at the idea]* 'Tisn't drink I'm looking for, Mr Flanagan. 'Tis other business entirely that brought me. I've been thinking of payin' you a call for some time.
Mick:	You wouldn't be selling property now, by any chance? The bit of land or the house or maybe both?
Maggie:	No, not the house! Lord save us, do you want me on the side of the road or stuck in a room in some back lane in Carraigthomond? 'Tis the field I came to see you about. I'm a poor widow woman and I want the best price I can get. They say you're an honest man to get the last half-penny for a person.
Mick:	*[Suddenly expansive, comes from behind the counter]* Sit down here, Maggie girl. I can guarantee you, you won't be wronged in this house. You came to the right spot. Am I right, Bird?
Bird:	No better man. As straight as a telephone pole.
Mick:	I suppose you know the Bird O'Donnell?
Maggie:	Only to see. How do you do, sir.

Mick:	How would you like a little drop of something before we get down to business? Something to put a stir in the heart.
Maggie:	Oh, Lord save us, no! I never touches it! Since the day my poor husband died, I never put a drop of drink to my lips. We used often take a bottle of stout together. *[Sadly]* But that was once upon a time. The Lord have mercy on the dead.
Mick & Bird:	The Lord have mercy on the dead!
Mick:	'Tis easy to see you're a moral woman. 'Twould be a brighter world if there were more like you.
Bird:	That's true, God knows. *[He picks up rings and returns to throwing position]*
Mick:	*[To BIRD]* 'Tis nothing these days but young married women guzzling gin and up till all hours playing bingo or jingo or whatever they call it. *[To MAGGIE]* You're a fine moral woman, ma'am. There's no one can deny that.
	[MICK goes behind the counter and locates a large pad. He extracts spectacles from convenient case and rejoins MAGGIE at the table. His manner is now more efficient and business-like]
Mick:	What kind of property do you wish to sell, Missus?
Maggie:	'Tis the four-acre field; the one you mentioned.
Mick:	There's a great demand for land these days. The country is full of upstarts, on the make for grazing. No shortage of buyers. *[Has poured himself a drink. Puts jotter on counter]* Now ma'am, your full name and address. *[He readies his jotter and pencil]*
Maggie:	Maggie Butler.
Mick:	*[Writes laboriously]* Mrs Margaret Butler. And the address?
Maggie:	Inchabawn, Carraigthomond.
Mick:	*[Writing]* Inchabawn, Carraigthomond. I know that field well. The one over the river.
Maggie:	That's the one . . . the only one.

[BIRD is now watching]

Mick: A handsome parcel of land. Fine inchy grazing and dry as a carpet. How do you hold it?

Maggie: What?

Mick: Your title? I mean, where's your title?

[MICK comes from behind counter, glancing at BIRD as he passes. Sits right of MAGGIE]

Mick: *[Kindly]* In other words, who gave you the right to sell it?

Maggie: 'Twas willed to me by my husband five years ago. 'Twas purchased under the Land Act by my husband's father, Patsy Butler. He willed it to my husband and my husband willed it to me. I'm the registered owner of the field.

Mick: That's fair enough for anything.

Bird: *[Closing in a bit]* I know that field. You let the grazing to the Bull McCabe.

Maggie: That's right. He has the grazing but only till the end of the month.

Mick: I fancy the Bull won't want to see it bought by an outsider. 'Tis bordering his own land.

[Look between BIRD and MICK. BIRD goes back to throw last ring or two]

Mick: And proper order, too. Well now, the acreage?

Maggie: Three acres one rood and thirty-two perches, bordering the river, with a passage to water and a passage to the main Carraigthomond road. 'Tis well fenced and there's a concrete stall in one corner near the river. There's two five-bar iron gates . . . and there's it's folio . . . 668420.

[BIRD finishes throwing rings, goes and gathers them together and hangs them on board. Then back to bar for rest of his drink]

Mick: And the valuation?

Maggie: Three pounds ten shillings, Poor Law.

Mick: Under fee simple, I take it?

Maggie:	Fee simple.
Mick:	Who's the solicitor, ma'am?
Maggie:	Alfie Nesbitt.
Mick:	No better man!
Bird:	*[Who had been whistling sotto voce]* The Bull McCabe won't like this!
Mick:	You're telling me!
Maggie:	Mr Flanagan, the highest bidder will get the field.
Mick:	Oh that you may be sure. But the Bull is sure to be the highest bidder. He needs that field. Well, Mrs Butler . . . Maggie . . . I'll stick a notice in the paper this evening and I'll have thirty-six bills printed and ready the day after tomorrow.
Maggie:	*[Gathering herself together and rising]* May God bless you, Mr Flanagan.
Mick:	It's my job, ma'am, it's my job. I suppose you'll have a reserve?
Maggie:	You'll put a reserve of £800 on it, Mr Flanagan.
Mick:	That's more than £200 an acre!
Maggie:	It's worth every penny of it. It's good land and it's well situated.
Mick:	True for you! True for you! You'll get the last brown copper for it. I'll make sure of that.
Maggie:	'Tis all I have apart from my widow's pension and I can't live on that. God will reward you if you get a good price for me. *[She rises]* Is there money going to you?
Mick:	No! No! That will come from the purchaser. Let me see then, we'll make it the fifth of April.
Maggie:	The fifth of April, please God. I'll see you then.
Mick:	Please God is right and God is good, ma'am. God is good.

[MICK sees her to the door]

Maggie: My husband always said you were an honest man, that I was to come to you if I was ever forced to sell. The Lord have mercy on him, he was a good honest man.

Mick: He was, to be sure. A good kindly innocent man.

Maggie: Good-day to you now.

Mick: Good-day to you, ma'am.

[Exit MAGGIE BUTLER]

Bird: You've a nice tricky job facing you now.

Mick: Don't I know it, but business is business, Bird, and business comes first with me.

Bird: The Bull McCabe won't like it.

Mick: What the Bull likes and don't like is nothing to me. I have my job to do.

[Enter MAIMIE, MICK'S wife, who has come downstairs]

Maimie: Bird.

Bird: Maimie.

Maimie: You're dinner is ready.

Mick: Good. I'll go right up. Will you type out a couple of copies of this for me?

[He hands her pages from jotter]

Maimie: How many do you want?

Mick: Make it three. Three should do. The Bird will carry one up to the printers when you're done.

Maimie: Don't be too long . . . I'll be going to the hairdressers when you come down.

Mick: Oh! What's on?

[MICK stops]

Maimie: *[Goes for typewriter behind bar]* Nothing's on, only that it's six weeks since I had my hair done.

Mick:	Why didn't you go and get it done before this? I don't like rushing my dinner. No one ever stopped you from getting your hair done.
Maimie:	No one . . . only nine kids. *[MICK glowers]* The baby's asleep, so you needn't turn on the wireless. If he wakes, that's the end of my hair-do.
Mick:	Cripes Almighty, woman, I want to hear the news.
Maimie:	Well, you can miss the news for one day.
Mick:	*[Turns again]* What's for dinner?
Maimie:	Corned beef and cabbage.
Mick:	Again?
Maimie:	What do you expect — turkey and ham?
Mick:	No, but God damn it, if I ate any more cabbage I'll have to put up a second lavatory.
	[Exit MICK]
Maimie:	*[Bringing typewriter to table and settling up to type — sitting]* No matter what you do, they aren't happy. What's for dinner, he asks. Ask him in the morning what he'd like for dinner and he'll tell you 'tis too soon after his breakfast.
Bird:	Put a half whiskey in that, will you?
Maimie:	Have you the price of it?
Bird:	No . . . but I'm selling two calves this evening.
Maimie:	Cash on the line only.
	[She inserts paper into typewriter]
Bird:	*[Rises and crosses with glass, drink not finished]* By God, you're an amazin' woman the way you keep up your appearance. I mean, after nine children, you're still the best-lookin' bird in Carraigthomond.
Maimie:	Come off it!
Bird:	'Twasn't me said that now, 'twas somebody else I'm quotin'. There was a bunch of us at the corner the other night and young Nesbitt started off about you. The way these young fellows talk about married women.

Maimie: The solicitor's son?

Bird: The very man! Just after you passed, he said 'there goes the finest-lookin' woman in the village'.

[He finishes drink]

Maimie: I'm not bad when I'm dressed up . . . if I had the time, that is. There's other good-looking women in Carraigthomond, you know.

Bird: Sure, there are . . . but it was you young Nesbitt picked out. He ought to know and he almost a doctor.

[Puts empty glass in front of her]

Maimie: I don't know why I listen to you. *[She takes his glass and pours a half-whiskey into it]* Not a word about this and make sure you pay me when you have it.

Bird: *[Follows to the bar]* Trust me! trust me!

Maimie: He's not a bad looking chap.

Bird: Who?

Maimie: Young Nesbitt.

Bird: Handsome, handsome.

Maimie: What had he to say for himself?

Bird: He never stopped talking for ten minutes. Couldn't figure out why you married your man.

Maimie: I hadn't much sense at nineteen. Nine kids in a dump where you wouldn't get a chance to see yourself in a mirror. The drapers won't even put panties in the windows here — hypocrites. *[She starts to type. Pause]* Do you know what kills me, Bird? It's watching those sanctimonious bitches on their way to the altar of God every Sunday with their tongues out like bloody vipers for the body of Christ, and the host is hardly melted in their mouths when they're cuttin' the piss out of one another again!

Bird: I don't know how you manage to look so good with all you have to do.

Maimie:	*[As if she hadn't heard]* If you get your hair done different they whisper about you. Dress up in a bit of style and they stare at you. You'd want an armoured car if you wore a pair of slacks. Do you know how long it is since he had a bath? A year! Imagine, a whole year! He changes his shirt every Sunday and sleeps in it for the rest of the week.

[Typing]

Bird: Amazing! Amazing!

Maimie: The last time he wore a pyjamas was seventeen years ago . . . the night of our honeymoon.

Bird: How you stick it, I don't know.

[MAIMIE continues to type. She reads a sentence]

Maimie: '. . . an unfailing water supply with . . . *[She cannot make out the word at first]* access to the river.' Spell access?

Bird: A...X...I...S

[Enter 'THE BULL' McCABE followed by his son TADHG. BULL wears a hat and overcoat, carries an ashplant . . . TADHG is well-built and sour. He is in his twenties and wears a cap]

Bull: Was oul' Maggie Butler in here?

Maimie: She only just left.

Bird: How's the Bull?

Bull: Who gave you the right to call me Bull, you pratey-snappin' son-of-a-bitch.

Bird: Sorry Bull, sorry.

[Retreats to head of counter]

Bull: *[To MAIMIE]* Where's Mick? *[Peering at what she is typing]*

Maimie: Upstairs, finishing his dinner.

[She covers typing, picks up the lot and goes behind counter]

Bull: Two bottles of stout and sixpence worth o' them round biscuits.

[MAIMIE goes for order]

Tadhg: You. Hump off!

Bird: Sure, Tadhg, sure.

[BIRD swallows whiskey and is about to depart]

Bull: Wait a minute! Sit down here. *[Indicates table]* Have a drink?

Bird: *[Nervously]* A half whiskey.

Bull: Three bottles o' stout, Maimie. *[To TADHG]* What do you suppose?

Tadhg: I'd say he knows all. Wouldn't you know by the cut of him?

Bull: I'd say so, too. *[To BIRD]* She was puttin' up the field, wasn't she, Bird?

Bird: That's right! Fifth of April is the day, by public auction.

Bull: You have a good ear, Bird.

Bird: She made no secret of it.

Tadhg: You'd think she might have told us.

[BULL grunts, rises and fetches the three bottles of stout from bar to table, also the bag of biscuits. He pays and leaves his ashplant on stage, right of counter]

Bull: Will he be long?

Maimie: He shouldn't be too long.

[BULL returns to seat. He takes a sip of stout and eats a biscuit, as does TADHG]

Bull: *[To BIRD]* The fifth of April, you say?

Bird: That's it! I was here.

Bull: Did she put a price on it?

Bird: £800.

Bull: She's out of her mind!

Tadhg: A head case!

[MAIMIE types and finishes, pulls out paper from machine. Then sits behind counter and reads paper]

Bird: 'Tis a good bit of land though, Bull. You'll have to admit that.

Bull: Oh, I'll admit it all right but 'twas the manure of my heifers that made it good. Five years of the best cow-dung in Carraigthomond and £40 a year for grazing. That's £200 I paid her, not counting the cost of the cow-dung and the thistles we cut year in year out. To me, that field isn't worth a penny over £400. I reckon if she got £200 more from me she'd be well paid. Wouldn't you say so, Tadhg?'. . . Bird, wouldn't you say so?

Bird: You're a fair man, Bull.

Bull: She'd be well paid indeed, if I was to fork out £200.
[BULL takes a drink]

Bird: Very well paid . . . but suppose there's other bidders, Bull?

Bull: *[Surprise]* There won't be any other bidders! I'll see to that. Half this village is related to me and them that isn't is related to my wife.

Bird: There's bound to be outsiders bidding. There's a craze for land everywhere.

[BULL points at his ashplant, which is near the counter, seizes it and strikes the floor with force. He brings drink with him and leans on counter]

Bull: That's what I care about outsiders. Accursed friggers with nothing in their heads only to own the ground we're walking on. We had their likes long enough, hadn't we? Land is all that matters, Tadhg boy, own your own land.

[BULL sits on stool, right end of bar]

Bird: You're right too, Bull. Dead right . . . Well, the wife will be wondering what's keepin' me. She'll have the dinner on the table by now.

[He rises to go]

Bull: You never ate a full dinner in your life and neither did your wife, you caffler, you! Whiskey is your dinner, supper and tea. How long since you ate an egg, you little rat, you, or a pound o' beef?

Bird:	*[Coming back]* Ah, now, she'll be worryin', Bull, an' you know what women are?
Bull:	Why wouldn't I? Haven't I one of my own, God bless her? *[Shouts]* Sit down. *[Shouts to MAIMIE]* What's he eatin' up there? *[BIRD sits]* A cow, is it?
Maimie:	He shouldn't be very long more.
Bull:	I suppose he's beginning his jelly and custard. That's good, Tadhg . . . jelly and custard.
	[TADHG rises and goes to BULL. Has bag of biscuits. Finishes drink]
Tadhg:	Da!
Bull:	*[Genuine affection]* Yes, Tadhg?
Tadhg:	We'll have to get this field.
Bull:	*[Squeezing TADHG's arm, taking bag of biscuits]* An' we'll get it, we'll get it, oul' stock. By all rights 'tis our property an' we're not men to be cheated out of our property.
	[TADHG seizes a few biscuits. BULL downs his stout and examines his pocket-watch]
Bull:	God, how I could frighten a feed of bacon and cabbage now, I guarantee you that. *[Shouts to MAIMIE]* Will he be long more?
Maimie:	I'll give him a call.
	[She comes from behind counter and goes to stairway]
Bull:	*[To TADHG and BIRD]* There's nothing like a Bull to move a heifer, hah!
Maimie:	Hurry on down, Mick, Mr McCabe want to see you.
	[There is a muffled reply from MICK]
Bull:	What did he say?
Maimie:	He's finishing his tea.
Bull:	His tea! Is it his supper or his dinner he's having'? Tell him to bring his tea down with him and drink it here.

Maimie:	Bring your tea down with you. Mr McCabe is in a hurry. *[Shouting upstairs]*
Bull:	Tell him myself had no dinner yet nor had Tadhg.
	[TADHG gobbles a few more biscuits]
Maimie:	He says he'll be down in a minute. *[Make this line almost a gibe]* He has to go to the toilet.
	[She sits behind bar]
Bull:	O, Merciful father! He can't eat his dinner without going to the lavatory!
Bird:	I'll slip away . . . I'll come back again if you want me for anything.
Bull:	*[Peevishly]* Can't you sit still? 'Tis no wonder they call you after a bird. You're worse than a bloody sparrow!
Tadhg:	He's here!
	[Enter MICK]
Mick:	How're the men? How's Bull, how are you? And Tadhg, how're you?
Bull:	We hadn't our dinner yet and the two of us fasting since morning.
Mick:	What can I do for you?
Bull:	*[Indicates MAIMIE]* 'Tis private.
Mick:	*[To MAIMIE]* Are you goin' to the hairdresser?
	[MAIMIE operates cash register and extracts a note. She exits without a word. As she is going off, BULL blows up the biscuit bag and bursts it]
Mick:	Well, now, what's the problem?
Bull:	The Bird here tells me you have a field for sale.
Mick:	That's right!
Bull:	You're aware of the fact that me and Tadhg has had the grazing of this field for the past five years and has the grazin' of it now?

Mick:	Yes, I am. Of course I am.
Bull:	Five times £40 is £200. A lot of money!
Mick:	'Tis a lot!
Bull:	I'll grant you 'tis a lot. A lot of countin' in hard-earned single pound notes.

[BIRD looks at BULL knowing what's coming]

Bull:	£200 in grazing alone. Who'd pay it but myself.
Mick:	Five forties is a fair sum.
Bull:	'Twould give me as much claim to the field as the woman who has it for sale.

[MICK doesn't answer]

Tadhg:	There wouldn't be a stitch of grass in it only for the manure of the heifers . . . our heifers!
Bull:	And the bullocks! Don't forget the bullocks, Tadhg. Our bullocks is more fat and content than women with husbands in England.
Tadhg:	'Twas us that kept the donkeys out of it.
Bull:	Donkeys! If there's one thing that addles me, it's wandering donkeys. I can't sleep at night over them. I swear to you I get into bed happy and there I'd be just settling down when I'd think of the long-eared thievin' pirates. No sleep for me that night. I keep thinking of the grass they eat on me, and the clover . . . the fine young clover.
Tadhg:	A hungry ass would eat as much as two cows.
Bull:	If he's an ass, he's after grass — someone else's grass. I often come across a lonesome ass in April when you'd see no growth anywhere an' you'd be sparin' the young fields for hungry heifers. Like the black stallion donkey with the single ear and the eyes like a saint?
Tadhg:	Oh, Christ!
Bull:	The first time I met that bastard was a Stephen's Day and he staring through one of the gates of the field we're buying now. You'd think butter wouldn't melt in his

mouth. To look at his face you'd think grass was the last thing in his head. He gave me a look and he trotted off. That night he broke the gate. Three months we watched him till we cornered him. Tadhg there beat him to death. He was a solid hour flaking him with his fists and me with a blackthorn . . . An' do you mean to tell me I have no claim to that field? That any outside stranger can make his open bid and do us out of what's ours, after we huntin' every connivin' jackass from the countryside?

Mick: Ah, now, Bull, be fair, she's entitled to the best price she can get. The field is legally hers.

Bull: An' she'll get a fair price. I'll hand you over £200 here an' now an' you'll give me a receipt.

Mick: £200! Ah, you'll have to do better than that. Anyway, 'tis for public auction on these premises, the fifth of April. 'Tis out of my hands, Bull . . . Sorry!

Bull: Is the bills out yet for it?

Mick: No, not yet.

Bull: Did you notify the papers?

Mick: I'm just on the point of doing it.

[Lifting MAIMIE's typing]

Bull: *[Pointing to it]* On the point of it, but 'tisn't done.

Tadhg: If it goes to the papers, you'll have twenty bidding for it.

Bull: We can't have that. *[Pause. Hand on typing . . .]* And we won't have that.

Mick: *[Detaches papers from BULL's hand]* The auction will have to be held.

Bull: And let it be held! There will be no one here but ourselves.

Mick: Ah, now, you know well there will be more than you interested. That's a good bit of land.

Bull: If it don't go to the papers an' if there's no bills who's going to know except what's here?

Mick:	You can't do that!
Bull:	'Twas done before. You did it yourself.
Mick:	This is different. Old Nesbitt, the solicitor, knows about this.
Bull:	He's an old crook and, if you ask me, he won't be here the day of the auction.
Mick:	What are you going to do? Kidnap him?
Bull:	There's a few old granduncles of mine with wills to be made. One of them could be dying that day, couldn't he? Oul' Nesbitt wouldn't want to fall out with our clan.
Mick:	Hold it! Hold it! I can't be a party to this. There's a reserve of £800 and the old woman needs the money. Besides, it's illegal.
Bull:	*[Laughs]* Illegal! That's a good one! *[Nudges his companions]* Did you hear that . . . illegal?
Mick:	There's my commission. Five percent of £800 is £40. I'm not going to lose £40 because you need a cheap field.
Bull:	*[Threateningly]* I need that field! I have nineteen acres and no passage to water. I have to get a passage. I'll pay you the £40 the day of the auction, provided my bid is accepted.
Mick:	I'd like to see that in writing.
Bull:	Writing? . . . Do you want me to be hanged? I'll sign nothing. Look! You needn't sign over the field 'till I plank the £40 into the palm of your hand.
Tadhg:	That's fair enough for anything, isn't it, Bird?
Bird:	'Tis reasonable.
Bull:	There will be something for Bird, too. We won't forget the Bird.
Mick:	You don't seem to understand that this is highway robbery.
Bull:	'Tis worse robbery the other way. Do you want some hangblasted shagger of a stranger to get it?

Mick: What about Maggie Butler? 'Tis her field and no one else's.

Bull: 'Tis as much mine! Look here, Flanagan, there's nothing to prevent a boycott of your shop.

Mick: What . . . what do you mean?

Bull: There's a hundred relations of mine in this village and around it. Not one of them will ever set foot in this pub again if I say so.

Mick: Give me the £40 now and I'll do my best.

[BULL laughs and TADHG moves to his left shoulder]

Bull: I'll give you the half of it. I'll give you £20 the day of the sale. Fair enough?

Mick: Fair enough! The Bird better keep his trap shut.

Bull: The Bird don't like to get his feathers wet. Do you, Bird? There's many a deep hole in the river below and who's to say how a man might lose his footing?

Bird: My lips are sealed.

[BULL draws a wallet from his pocket and extracts two tenners]

Bull: *[To MICK]* Here's two ten pound notes. The Bird here will act as a witness. Put your hand here, Bird, *[He places BIRD'S hand over MICK'S]* and say after me *[Authoritative tone]* . . . As God is my judge . . .

Bird: As God is my judge . . .

Bull: I swear by my solemn oath . . .

Bird: I swear by my solemn oath . . .

Bull: That I witness the receipt of £20 by Mick Flanagan . . .

Bird: That I witness the receipt of £20 by Mick Flanagan . . .

Bull: Of the first part . . .

Bird: Of the first part . . .

Bull: From the person of Thady McCabe of the second part . . .

Bird: From the person of Thady McCabe of the second part . . .

Bull:	*[Proudly with grim humour]* Here-in-after, affectionately known as the Bull . . I'm no fool when it comes to law, boys.
Tadhg:	Hear! Hear!
Bull:	I'm as big a rogue as any solicitor.
Mick:	I'll have to get the bills printed but I'll get the lot burned when they come from the printers.
Bull:	Solid thinking . . . very solid! Now, here's what we'll do. The morning of the auction the Bird here opens the bidding with a £100 and I rise him £10. *[Increasing in tempo]* The Bird goes to £120 and again I rise him £10. The Bird soars up to £150 and again I rise him £10. The Bird flies higher to £190 but I'm there with the final bid of £200. All straight and fair and above board. Two down, as the man said, and carry one. What about the printer? Is he trustable?
Mick:	Safer than a confession.
Bird:	What about me, Bull?
Bull:	What about you?
Bird:	You promised me something.
Bull:	What would you say to £5?
Bird:	I'll take it.
Bull:	The minute the land changes hands, 'tis yours.
Bird:	What about a £1 on deposit?
Bull:	*[Wounded]* Is it how you don't trust me?
Bird:	No . . . No . . . Good God, no!
Bull:	You won't be forgot, Bird. You have my guarantees on that.
Bird:	Stand us a half-one before you go?
Bull:	Give him a half-one, Mick. We'll all have one. Have one yourself, Mick.

[BULL throws coin on counter and MICK goes to fetch

whiskey]

Bull:	*[Leaning on bar, in an ecstasy of accomplishment]* I watched this field for forty years and my father before me watched it for forty more. I know every rib of grass and every thistle and every whitethorn bush that bounds it. *[To BIRD]* There's shamrock in the south-west corner. Shamrock, imagine! The north part is bound by forty sloe bushes. Some fool planted them once, but they're a good hedge. This is a sweet little field, this is an independent little field that wants eatin'.
Bird:	Well, you'll have it soon *[Accepts whiskey from MICK]* with the help of God.
Bull:	*[Looks at him suspiciously for a moment but goes on]* When oul' Maggie's husband died five years ago, I knew he was dying. One look at the writin' under his eyes and I knew. I knew the wife was feeling the pinch lately. I knew by the writin'. 'Twas wrote as plain as a process across her forehead and in the wrinkles of her cheeks. She was feelin' the pinch of hunger. *[Suddenly to BIRD who becomes transfixed]* Bird, I swear to you that I could tell what a man be thinking by the writin' on his face.
Bird:	Have no fear o' me!
Bull:	*[Affable]* I won't oul' stock, for I know you're to be trusted above any man I know.
Tadhg:	Da, what about the dinner?
Bull:	*[Proudly]* There's your healthy man! When he isn't hungry for women, he's hungry for meat. Tadhg, my son, marry no woman if she hasn't land.
	[Enter a youngish sergeant of civic guards in full uniform]
Sergeant:	Good afternoon, men!
Mick:	Ah, good afternoon to you, Sergeant Leahy. Would you care for a drink?
Sergeant:	Thank you, no, Mick.
Bull:	*[To TADHG]* Come on away or our dinner will be perished.
Sergeant:	I didn't call to see you, Mick. I came to have a word with

Mr McCabe here.

Bull: Well, you'll have to postpone it because I'm going to my dinner.

Sergeant: This won't take long. I'm here investigating the death of a donkey.

[Laughter from all]

Bull: Investigating the death of an ass! You wouldn't hear it in a play! By gor! 'Tis the same law the whole time. The same dirty English law. No change at all.

Sergeant: Maybe not, but I have to ask your son and yourself a few questions.

Bull: You're out of your mind, Sergeant. Come on away home, Tadhg. God, have ye anything else to do? What about all the murders and the robberies? 'Twould be more in your line to be solving them. Come on, Tadhg, this fellow is like all the rest of 'em. His brains are in the arse of his trousers.

Sergeant: *[Sharply]* That's enough of that! Sit down and answer my questions . . . sit down or come to the Barracks!

Bull: Sit down, Tadhg . . . *[Smugly]* There's more thought of donkeys in this world than there is of Christians.

Sergeant: Where were you the night before last?

Bull: What night was that?

Sergeant: *[To TADHG]* Where were you last night?

Tadhg: Where's that we were again, da?

Bull: We were at home playing cards.

Sergeant: Until what time?

Bull: Till morning.

Sergeant: And did you leave the house during that time?

Bull: We were in the backyard a few times, or is that ag'in the law, too?

Sergeant: Can you prove that you didn't visit Mrs Butler's field over

the river on that night?

Bull: On my solemn oath and conscience, if we left the house for more than two minutes.

Sergeant: You have that field taken for grazing, haven't you?

Bull: Everyone knows that.

Sergeant: Well, can you prove you weren't there?

Bull: The Bird there was playing cards with us till two o' clock in the mornin'.

Sergeant: Is that the truth, Bird?

Bird: Gospel!

Sergeant: Well, the donkey was killed around midnight. His cries were heard by a couple walking along the river. They reported to the SPCA who in turn reported it to the Barrack Orderly. What I want to know is where were ye when the donkey was poisoned?

Tadhg: He wasn't poisoned!

Sergeant: How do you know he wasn't poisoned?

Tadhg: Well . . .

Bull: Because there's no poison on our lands. That's how he knows an' don't be doin' the smart man with your tricky questions. What is he but an innocent boy that never told a lie in his whole life. You don't care, do you, so long as you can get a conviction. Tell me, where do you disappear to when there's tinkers fightin', an' law-abidin' men gettin' stabbed to death in the street?

Sergeant: Bird, you say you were at this man's house that night and I say — you're a liar!

Bird: Ye all heard it! Ye all heard what he said! You called me a liar, Sergeant, and no man does that to the Bird O'Donnell. No man — uniform or no uniform.

Sergeant: All right! All right! I take it back. I apologise for calling you a liar.

Bird: You better not do it again! *[Somewhat mollified]*

Sergeant: I'm wasting my time! There's nothing in your heads but pigs and cows and pitiful patches of land. You laugh when you hear that an old jackass was beaten to death, but a man might be beaten to death here for all you'd give a damn.

[Exit SERGEANT LEAHY]

Bull: And a Sergeant might get his face split open one night and all the guards in Ireland wouldn't find out who did it . . . not if they searched till Kingdom Come!

Scene 2

[Action takes place as before.

The time is the morning of April the fifth. MAIMIE FLANAGAN is behind the bar. Three of the children are playing in and around the bar area. The BIRD is seated at table with a glass of whiskey in front of him. The BIRD rises and approaches the counter. He brings his whiskey along with him and swallows it at the counter. He places glass on counter and takes coin from his pocket which he places on the counter]

Maimie: Good girl, Nellie, will you go upstairs and look after the baby?

Bird: Throw a drop of whiskey into that, will you? *[He carefully arranges money on the counter]* Just enough!

[Enter boys from the street]

Bird: Close the bloody door, I'm perished.

[MAIMIE pours whiskey, takes money and places it in cash register]

Maimie: *[To boys]* Upstairs!

Bird: I see you got your hair done.

Maimie: About time, wasn't it?

Bird: It suits you. *[Surveys it from an angle]* Definitely suits you. Kind of a girly look.

Maimie: *[Touches her hair up]* D'you think so? 'Tis the latest . . . well, the latest around here anyway . . .

[Enter LEAMY with a box of stout]

Leamy: My father said you were short of stout.

Maimie: Thanks, Leamy. What's he doin' up there?

Leamy: Listenin' to the wireless. The baby's crying, Muddy. What'll I do with him?

Maimie: Give him a suck out of the bottle and if he doesn't settle down, call me, Leamy.

Leamy: All right, Muddy.

Maimie: Aoife, take Mary upstairs. Leamy, take this fellow upstairs, there's an auction going on here this morning.

Leamy: *[To BIRD who is now throwing rings]* Bird, you'd hook a farmer quicker than you'd hook a thirteen.

[Exit LEAMY, mock-chased by BIRD]

Maimie: Well, did he like it?

Bird: What?

Maimie: Me hair.

Bird: Who?

Maimie: The fellow you told me about. Young Nesbitt, the solicitor's son.

Bird: Oh, he was on about you again the other night.

Maimie: What did he say?

Bird: How did a good-looking woman like Maimie Flanagan get stuck in a dump like this? That's what he said . . . how did she get stuck in a dump like this?

Maimie: Stuck is right! He seems like a nice young fellow. Why don't you bring him in for a drink sometime? Or does he drink?

Bird: Does he what? He doesn't drink around here, though . . . too much talk. You can't blame him. You know what they're like around here?

Maimie: You're right there! You couldn't turn in your bed but they'd know it.

Bird: There's a lot of jealousy. It must be a holy terror to be a good-lookin' woman an' all them oul' frowsies gabbin' about you. An 'tis worse if you're not appreciated by them who should appreciate you.

Maimie: Sure, even if I talk to any good-looking fella in the bar, himself does be mad jealous. You'd think I was goin' to run away with one of 'em.

Bird: No one but yourself would stick it. You've got the patience of Job.

Maimie: Oh, he can be terrible. D'you remember the time last year I went to the dance in town . . . that I thought he'd be spending the night in Dublin?

Bird: You looked good that night. Mind you, I wasn't the only one who remarked it.

Maimie: Four years since I was at a dance, and imagine. . . . on that one night he should get a lift home unexpectedly!

Bird: *[Gets off stool and comes to her]* What did he do?

Maimie: Waited up till I came home. I asked a few of the boys in for a drink and he hiding all the time around in the stairway. *[The BIRD whistles]* Heard every word we said. Luck o' God, 'twas all innocent. He got a great suck-in. It's a pity I didn't know he was listening I'd have stuck in something deliberately.

Bird: A pity!

Maimie: 'Twould have been great gas if we all knelt down and said the Rosary.

Bird: But what happened? What happened?

Maimie: Oh, he waited till the boys were gone and there he was, sitting on the steps of the stairs as I was going up. Christ, I thought I'd drop dead . . . he struck me and I fell down the stairs. I pretended to be unconscious. That frightened him. You should have heard him! Oh, the lamenting would

bring a laugh from a corpse.

Bird: Good! . . . Good! . . . Go on!

Maimie: 'Wake up, Maim. Wake up, my little darling!' he never called me darling before, not even when we were courting. He got a bit annoyed then. 'Wake up, Maimie! will you wake up, in the name o' God, and don't disgrace me by being dead . . .'

Bird: This is marvellous! . . . marvellous! . . .

Maimie: Wait till you hear! 'Wake up,' said he and he started sobbing. 'Wake up, you bloody bitch. You want to have me hanged!' *[Both laugh]* He said the Act of Contrition into my ear after that and rushed over for the doctor and the priest. I had a brandy while I was waiting.

Bird: Ah, this is priceless! . . .

Maimie: Bird, were you ever anointed? *[BIRD looks askance at her]* Oh, it's a great sensation when you aren't sick . . . more soothing than getting your hair done . . . something like a massage . . .
 [At this stage a newcomer enters and nods both to MAIMIE and the BIRD. He is a young man in his late twenties, well-dressed and presentable. He is WILLIAM DEE]

Maimie: Good morning.

William: Good morning.

Bird: Good morning.

Maimie: Nice morning, isn't it?

William: Yes, it is. Could I have a bottle of beer, please?

Bird: 'Tis inclined to be a bit showery, but all in all, 'tisn't bad for the time of year.

William: April is a tricky month all right. You never know where you are with it.

Bird: Like a woman!

William: *[Considers this observation]* Yes, in some ways . . . Yes, it is! It's a strange month.

Bird:	Fine one minute and wet the next. *[Playing with his glass]* I hate windy weather. I'm told there's good growth though. Should please the farmers.
William:	A very difficult thing to do.
Bird:	You aren't far wrong there. *[Sarcastically]* Still, they had a hard winter and they deserve a bit of comfort, the creatures!
Maimie:	*[Placing drink on the counter]* Now, there you are!
	[WILLIAM places money on the counter]
Bird:	Good luck! *[Finishing drink ostentatiously]*
William:	Would you care for a drink, sir?
Bird:	Yes, indeed . . . a large whiskey, Maimie, please.
	[MAIMIE fills the BIRD's glass and takes the price of it from WILLIAM's change]
Maimie:	You're a stranger to these parts.
William:	My wife was born around here. So I'm not a stranger . . . not a complete stranger, that is.
Maimie:	Where was your wife born?
William:	About six miles away . . . a place called Tubber.
Maimie:	What was her name?
William:	Connolly.
Bird:	*[Thoughtfully]* Connolly! . . . Connolly! . . .
Maimie:	I can't seem to place her.
Bird:	Neither can I.
William:	Well, that would be pretty hard for you. There's nobody of that name in Tubber now. The whole family moved to England twenty years ago.
Maimie:	And are you from around here?
William:	No. I'm a Galway man. I live in England. Living there twelve years. Me, if I had my way, that's where I'd like to stay.

Maimie:	Is your wife with you?
William:	No . . . she's in England. She may be joining me soon. It all depends.
Maimie:	You're on holiday?
William:	No . . . business. That's why I'm here. I came to see your husband. If he's around I'd like a few words with him.
Maimie:	He's finishing his breakfast. I'll slip up and get him if you like. It's no trouble.
William:	No, there's no hurry. Will you have a drink? I should have asked you in the first place.
Maimie:	I don't know that I should!
Bird:	Go on, for God's sake! You'll only be young once.　*[To* WILLIAM] This is our local beauty queen.
Maimie:	Don't mind him! . . . 'Twill have to be quick.
Bird:	We won't tell . . . cross our hearts!
Maimie:	I'll have a drop of brandy, so.
	[WILLIAM places money on counter]
Bird:	A gay soul, this one, as game as any.
Maimie:	Here's cheers!
Bird:	Good luck!
Maimie:	*[Tosses back her drink quickly]* Now you'll have to have one on me.
William:	Not for me, thanks. Too early!
	[BIRD swallows his drink quickly and proffers his glass]
Bird:	I won't say no, Maimie.
Maimie:	It has to be a small one this time. We don't want him drunk, do we, Mister . . .?
William:	The name is Dee . . . William Dee.
Maimie:	Mr Dee, are you sure you won't have one?
William:	No, if you don't mind. Some other time, maybe. I'll be

here for a few days *[Sits on chair at table]* and it's possible
I'll be here permanently.

*[MAIMIE fills BIRD'S drink and hands it to him. Takes
WILLIAM'S money, gets change and gives it to him]*

William: Your husband is Michael Flanagan, the auctioneer, isn't he?

Maimie: That's right! I'll slip up and get him. *[Suggestively to DEE]*
Drop in again, some time, any time . . . Bird.

Bird: Maimie!

[Exit MAIMIE]

William: Seems like a nice woman.

Bird: You needn't say this to anyone . . . but she's a regular flier,
that one. Thirty, thirty.

William: *[Somewhat coldly]* She struck me as being a nice friendly
woman.

Bird: Ah, I was only having a bit of a joke. You're right about
her, though. She's lovely.

[MICK appears at stairway]

Mick: Good morning, gentlemen! *[To WILLIAM]* The wife tells me
you were wanting to see me.

William: I'm sorry if I disturbed you. There's no particular hurry.

Mick: That's all right. I was only listening to the late news . . .
What can I do for you?

William: Well, first of all, let me introduce myself. My name is
William Dee.

Mick: I'm Mick Flanagan. *[He shakes hands with WILLIAM]*
How do you do?

William: I have a letter here from Mr Nesbitt, the solicitor, about the
sale of a field. *[Looks at watch]* The auction was supposed
to take place at eleven o' clock today. Maybe, there's been
a mistake . . .

Mick: No, there's no mistake. This is the day of the auction, all
right. But who told you? How did you get in touch with
oul' Nesbitt?

William:	It's the wife, you see. Since our last baby her nerves haven't been too good and she wants to come back to Ireland. Mr Nesbitt was one of the many solicitors I wrote to, to be on the lookout for just such a field. Last week I had a letter from him so I took a chance and came over. Sláinte!

[MICK picks up WILLIAM'S empty glass and goes and fills half-pint]

Mick:	You may have come on a fool's errand.

[MICK gives the beck to the BIRD who finishes his drink and exits quickly]

William:	I don't understand.
Mick:	There's only four acres . . . you couldn't possibly make a living there.
William:	I'm not worried about that. My site in England is much less.
Mick:	Don't get me wrong now, my friend. I'm only advising you for your own good.
William:	I've a business of my own in England and I do fairly well. I supply concrete blocks to builders. This field is the right size for me. It's on a river with first-class gravel.
Mick:	Who told you? About the gravel, I mean?
William:	I had an engineer from the town look it over.
Mick:	An engineer! That must have been the fellow with the wooden box. Said he was catching eel fry . . . You'd want a fortune to start a business like that!
William:	It's not as difficult as it sounds. I cover an acre or so with concrete, move in my machinery and I'm in business.
Mick:	*[Putting free drink before WILLIAM]* It's only fair to tell you there's a boycott on outside bidders.
William:	Nesbitt said nothing about a boycott.
Mick:	Well, that's the way it is. There's a boycott all right and there could be trouble . . . serious trouble.
William:	What sort of boycott?

Mick:	I wouldn't want to lead you astray but for the past five years now a farmer whose land is right next to the field has rented the grazing. He believes he has first claim . . .
William:	It's a public auction, isn't it?
Mick:	Yes . . . yes . . . but I thought I'd warn you. The village would hold it against you.
William:	I wouldn't be selling blocks to the village.
Mick:	You wouldn't get men to work for you.
William:	A few of my men in England would give their right hands to get back to Ireland.
Mick:	You don't know about land. You're a stranger . . . you wouldn't understand. There will be trouble.
William:	All I know is that my wife isn't well. If I don't get her back here quick, she'll crack up. Now, if that isn't trouble, tell me, what is?
Mick:	Look! I'll tell you what . . . you go back to your wife and I'll find a suitable field for you. I won't let you down. I'll search high and low. You won't have long to wait.
William:	You're an auctioneer?
Mick:	Yes.
William:	And this is a public auction?
Mick:	Yes.
William:	Well, I'm a prospective buyer, so how about getting along with the auction?
	[Enter MAIMIE with a tea-tray. She comes between them]
Maimie:	*[To WILLIAM]* Would you like a cup of tea?
	[MICK glowers at MAIMIE as she places tea on table]
William:	Thanks, I would.
Mick:	D'you know what he's doin'?
Maimie:	No . . . what?
Mick:	He's biddin' for the field!

Maimie:	What's so awful about that?
Mick:	*[Furious]* Cripes Almighty, woman!
	[MAIMIE exits with the tea-tray]
William:	I'm not so welcome, am I?
Mick:	Look, I've nothing against you personally.
William:	And I've nothing against you, personally or otherwise.
	[Enter MAGGIE BUTLER]
Mick:	Ah, there you are, Mrs Butler. You're welcome!
Maggie:	Is it time for the auction yet?
Mick:	Any minute now. We're waiting for the bidders.
Maggie:	There don't seem to be many here.
Mick:	It won't be so. It won't be so, I assure you.
	[Enter MAIMIE]
William:	*[To MAGGIE]* Are you the owner of the field?
Maggie:	I am, sir.
William:	I'm pleased to meet you. My name is Dee . . . William Dee. I expect to be bidding for your property . . .
Mick:	*[Confidentially to MAGGIE]* It might be better if you weren't here until the auction starts. Why don't you go upstairs with Maimie for a cup of tea?
Maimie:	Aye, Maggie, do.
Maggie:	Very well. *[She rises and MAIMIE solicitously takes charge of her]* You'll do your best for me, Mr Flanagan?
Mick:	We'll do our best, our very best.
Maggie:	You'll be sure to call me, Mr Flanagan.
Mick:	To be sure, to be sure.
Maimie:	Come on this way, Maggie, watch the toys.
	[Exit MAGGIE and MAIMIE]
William:	As a prospective buyer, I have a right to know everything

about the field.

Mick: You know too bloody much!

William: I know how to look after myself.

[Enter the BIRD. He sidles to counter and rests his elbows on it, watching MICK and WILLIAM. He is followed almost immediately by the BULL McCABE who carries an ashplant. Following the BULL, comes his son, TADHG. They both glare at WILLIAM who is somewhat surprised by their attitude]

Bull: *[Stops inside door to survey WILLIAM]* Give us three half pints o' porter.

William: Hello there.

[MICK goes behind counter to draw the stout. The BULL scowls at WILLIAM who is somewhat amused by his antics]

Bull: We were told about you. Are you aware there's an objection here?

William: So I'm told.

Bull: What do you want the field for?

William: That's no business of yours.

Mick: He's going to make concrete blocks.

Bull: What?

Mick: To cover the field with concrete.

Bull: What about the grass? What about my lovely heifers?

Tadhg: No more meadows nor hay? *[To WILLIAM]* You're an oily son-of-a-bitch!

Bull: No foreign cock with hair-oil and a tie-pin is goin' to do me out of my rights. I've had that field for five years. It's my only passage to water. You're tacklin' a crowd now that could do for you, man. Watch out for yourself.

[MICK arrives with three bottles of stout]

Bull: Give us sixpence worth of biscuits — far-to-go ones.

William: *[To MICK]* Isn't it time the auction was started?

Bull: If you know what's good for you, you won't bid.

William: Is that a threat?

Tadhg: *[Intimidating]* Make what you like of it!

William: If you care to make youself clear, I certainly will

Tadhg: *[Fighting pose]* If you fancy yourself, you can have it here.

William: For God's sake, be your age!

[WILLIAM rises, goes to stairway and calls for MAGGIE BUTLER before anybody can stop him]

William: *[To others]* I think you'll all agree that Mrs Butler should be present. She *is* the rightful owner, I believe.

Mick: Mrs Butler, I'm going to start the auction now.

[MICK places bag of biscuits on table and accepts money from BULL]

Bull: *[To MICK]* He'll get his head split if he isn't careful. Bloody imported whoresmaster, taking over the village as if he owned it.

Mick: I want no trouble here now, Bull. There's a way for circumventing everything.

Bull: I'll circumvent him, if there's circumventing to be done.

[Enter MAGGIE BUTLER followed by MAIMIE]

Mick: Mrs Butler, take a seat.

[Reluctantly MICK goes behind counter and emerges with two long slips of white paper]

Mick: I'll read the conditions of sale. *[Stands on a low box]* The highest bidder shall be the purchaser and if any dispute arises as to any bidding, the property shall be put up again at the last undisputed bidding. There will be a reserve price and the vendor and her agents will be at liberty to bid. No person shall advance less than five pounds at any bidding and no bidding shall be retracted . . .

Bull: I see the dirty hand of the law in this!

Mick: *[Reading]* 'Two . . . The purchaser shall immediately on

being declared as such, pay to the Auctioneer one-fourth
of the purchase money as a deposit together with the usual
auction fees of five per cent . . .' And so on and so forth,
et cetera, et cetera.

*[MICK hands form to MAIMIE who places it on counter. BULL
snatches the paper]*

Bull: Law! Law! *[To TADHG]* that's the dear material. All the money
in Carraigthomond wouldn't pay for a suit length of that
cloth.

[He slams form back on counter]

Mick: And now the 'Particulars and Conditions of Sale' . . .
[Reads from second paper] 'Particulars and Conditons of
Sale by Auction of the undermentioned property pursuant
to advertisement duly published for the purpose . . .'

Bull: Oh, merciful God, that's the rigmarole. Start the bidding
and get it over.

Mick: *[Hands paper to MAIMIE]* . . . Now, this land, as you all
know, is well watered and well fenced with a carrying
power of seven cattle . . .

Bull: Thanks to me and Tadhg. 'Twas our sweat that fenced it
and our dung that manured it. Come on, man, get on with
the bidding!

Mick: Do I hear an opening bid for this excellent property?

*[BULL, TADHG and the BIRD sip their stout and nothing is to
be heard unless it is the sound of TADHG crunching
biscuits]*

Mick: I repeat, ladies and gentlemen, will someone bid me for
this fine field on the banks of the Oinseach river. *[Pause]*
This property of three acres one rood and thirty two
perches or thereabouts. This green grassy pasture . . .
[Pause] . . . come on now! . . . Do I hear an opening bid?
. . . Will someone bid me, please!

*[BULL nods at the BIRD and the BIRD shuffles a pace
forward]*

Mick: Do I hear a bid?

Bird: £100

Mick: I hear you loud and clear, sir. £100 it is from the Bird O'Donnell . . . Now, this is more like it. Do I hear any advance on £100.

[All eyes are turned on WILLIAM who calmly lights a cigarette]

Bull: £110.

Mick: £110 from Mr Thady McCabe.

Bird: £120

Mick: £120 from Mr Bird O'Donnell.

Bull: £130.

Mick: Do I hear . . . Do I hear an increase on £130? Do I hear an increase on £130?

Bird: £150.

Mick: £150. Do I hear — ?

Bull: £160.

Mick: £160 from the Bull McCabe. Do I hear any advance on £160?

[At this stage they all look at WILLIAM who smokes on unperturbed]

Bird: £190.

Mick: Any advance on £190? Any advance on £190?

Bull: £200!

[Pause]

Mick: I have £200. Do I have any advance on £200? On £200? I have £200 from Mr Thady McCabe of Inchabawn . . . *[Again WILLIAM is the subject of all eyes]* Is this to be the final bid? There is a reserve and I will negotiate by private treaty with the highest bidder. C'mon now, ladies and gentlemen. Before I close this public auction, do I hear any advance on £200?

William: *[Casually]* Guineas!

Mick:	Any advance on £200?
William:	Two hundred guineas.
Tadhg:	What's guineas?
Bull:	He should be disqualified. There's no such thing as a guinea going these days.
William:	All right. I'll bid £300.
	[An audible hush]
Mick:	*[Nervously]* I have £300 . . . have I any advance on £300? I'm bid £300. Do I hear £350? Do I hear £350? No! . . . In that event, I'll call a recess for a day and negotiate by private treaty.
	[MICK is about to turn away but WILLIAM rises and stops him]
William:	What time do you propose to start tomorrow?
Mick:	Oh, some time in the morning. We can't all be on the dot like you. These people here are hardworking people with little time to spare.
William:	What guarantee have I that you won't close the deal with him? *[Indicating BULL]*
Mick:	Now, let that be the least of your worries. Everything is nice and legal here.
William:	I take it then that my bid being the highest, you'll give me something in writing until morning.
Mick:	*[Anger]* You'll get no bloody writing from me . . . You'll be here in the morning if you want to bid again.
William:	Bid against whom?
Mick:	*[For the benefit of MAGGIE BUTLER]* You'll bid till this woman's reserve has been reached. There's no one going to wrong an old woman, not while I'm on my feet, Mister. I'll give you a guarantee of that.
William:	How much is the reserve?
Mick:	£800.
William:	That's not beyond me and I'm prepared to bid again.

When can I see the field?

[TADHG and BULL step forward]

Tadhg: Stay away from that field.

Bull: There's cattle of ours there.

William: If the field is for auction, I'm entitled to have a look at it.

Bull: Use your head while you're able. Stay away!

Tadhg: That's right! Get the hell out of here now . . . while you can.

Maggie: You can see my field any time, sir.

Bull: *[Roars]* Shut up, you oul' fool! What about my claim?

Maggie: You've no claim!

Bull: *[Dangerously]* Look out for youself, you! Look out for
 youself. *[He cows the old woman]*

William: I'll be back when you open in the morning.

Bull: That field is mine! Remember that! I'll pay a fair price. God
 Almighty! 'Tis a sin to cover grass and clover with concrete.

 [MAGGIE BUTLER rises and moves towards doorway]

Maggie: *[To MAIMIE]* I'll have to be goin'. There's no one in the
 house but myself.

Bull: You should remember that!

 *[MAGGIE looks back, startled. WILLIAM acknowledges MAGGIE'S
 exit]*

Bull: *[To WILLIAM]* Get out while you're clean!

William: I'll be back in the morning . . . and this time I'll be with
 my solicitor.

 [WILLIAM exiting]

Bull: You might be back with more than your solicitor.

 *[WILLIAM exits. BULL, TADHG and MICK go into a huddle at the
 counter. The lights fade]*

[Action takes place in the pub late that evening. LEAMY is at the door looking out MAIMIE is outside bar, watching him]

Maimie: *[To LEAMY after opening pause]* It's quiet, Leamy. You could have gone out with the boys.

Leamy: I'd rather be here with you, Muddy. You go out for a walk and I'll be OK. There won't be anybody in for a while.

Maimie: A funny thing, Mister, I'd rather be here with you, too. Give my back a rub like a good boy. *[LEAMY does so]* Oh, that's lovely!

Leamy: I wish it was always like this.

Maimie: Sit down, Leamy, and we'll treat ourselves to a drink.

Leamy: You stay there and I'll get it. *[He seats his mother]* Now, what'll it be? The sky's the limit!

Maimie: I'll have a drop of brandy. Are they asleep upstairs?

Leamy: All sound! . . . A small brandy it'll be.

[He goes behind counter]

Maimie: I haven't sat down since morning. It's like a holiday having a stretch. *[She yawns]* I wonder what it's like to have a job that ends at six with Saturdays and Sundays free and holidays. Can you imagine, Leamy . . . holidays. Sure, if we had holidays we wouldn't know what to do with 'em.

Leamy: *[Places drink on table and sits down]* Would you like a cigarette?

Maimie: Aye, they're over there by the register. You're a great boy! *[Lifts her glass]* Long life, Leamy!

Leamy: And the same to you, Muddy! *[They drink]* Do you feel it, too?

Maimie: Feel what?

Leamy: The fear! I'm getting afraid already. I'll bolt the door and put up the shutters and let nobody in. Let's just sit here and never open that old door again.

Maimie: I know what you mean, Leamy.

[Someone approaches from outside]

Maimie: Take the glasses, quick!

Mrs McCabe: Ah, wait for me, will you!

Dandy: C'mon. C'mon.

[LEAMY takes the glasses and hurries behind the counter. Enter DANDY McCABE and his WIFE. His WIFE trails behind him, wearing a shawl]

Dandy: Good evening, Maimie!

Maimie: Dandy, Mrs McCabe.

Mrs McCabe: Hello, Maimie.

Maimie: What can I do for you?

Dandy: Give us a gargle first. *[To WIFE]* What do you want?

Mrs McCabe: A tint of peppermint.

Dandy: Give her a peppermint and give me a half o' rum.

Leamy: I'll get them, Muddy.

Maimie: Good boy, Leamy.

Dandy: Is the boss in?

Maimie: He should be back shortly.

Dandy: You'll do, just as nicely. I want to pay him for that acre of bog. Will you see if he has it in the books?

Maimie: Sit down, I won't be a minute.

[Exit MAIMIE]

Dandy: *[To WIFE]* C'mon, c'mon, c'mon, c'mon! Sit down there you, in a place where I can be admiring you.

[LEAMY emerges with drinks and places them on table]

Dandy: You're the oldest boy, aren't you?

Leamy: Yes sir!

Dandy: Call me Dandy, man. They all call it to me. Them that don't do it to my face, do it behind my back. What's your name?

Leamy: Leamy!

Dandy: Leamy, Dandy!

Leamy: Leamy, Dandy!

Dandy: You're called after your grandfather, Leamy Flanagan. A decent man he was. Too fond of his drop. A good man's case. How much is due to you?

Leamy: Three shillings.

Dandy: *[Locates money]* A horse and a hound is three shillings and a tanner for yourself.

Leamy: Thanks very much.

Dandy: Thanks very much, Dandy.

Leamy: Thanks very much, Dandy.

Dandy: Simple, isn't it? *[Indicates WIFE]* You know this one?

Leamy: Yes, Dandy.

Dandy: Married twenty-four years and never a cross word between us.

Leamy: *[Beginning to enjoy himself]* That must be a record.

Dandy: Say 'Dandy'.

Leamy: That must be a record Dandy.

Dandy: *[Conspiratorially]* And I'll tell you something else. To go no further. *[LEAMY nods]* If she liked she could be married to the Aly Khan.

[The wife hits him on the arm and nearly collapses with laughter]

Dandy: Met her when I was in the army. Love at first sight. Bet you can't guess why I brought her to town tonight . . . go on, guess.

Leamy: I couldn't guess, Dandy.

Dandy: *[Looks around mysteriously]* Word of a man. Shake hands on it. To go no further. *[LEAMY shakes his hand . . . conspiratorially . . .]* I'm buying an aeroplane for her.

[Wife hits him on arm and laughs to her heart's content. So does LEAMY]

Dandy: She has one weakness though, only the one . . .

Leamy: What's that, Dandy?

Dandy: She won't eat canaries. I boiled a canary for her yesterday and stuffed him with ginger. Wouldn't look at it . . . *[Laughter]* . . . had to give it to her mother.

[Enter MAIMIE with a ledger. LEAMY goes behind counter and puts money in cash register]

Maimie: *[Reading from ledger]* One acre of turbary purchased last January, including fees, thirty-six pounds ten. It's here all right, Dandy.

Dandy: And I'm here, too. *[Takes wallet from inside pocket and extracts money]* Here's your money, Maimie. Three tenners, a fiver, pound note, ten shillings, that's thirty-six pounds ten.

Maimie: *[Accepts money and counts it]* It's all here, Dandy.

Dandy: And I'm all there!

Maimie: I'll cross it off the book and get your receipt.

[MAIMIE goes behind counter to cash register and ledger. DANDY rises to his feet, finds MICK's auctioneering hammer and fondles it briefly]

Dandy: Will I have another? *[To MRS McCABE]* Will you have one?

Mrs McCabe: Not for me.

Dandy: I'll have the same again, Leamy. *[Lifts hammer]* There's a hammer that never drove a nail. Ladies and gentlemen. I have here for sale, one prime farmer's wife, fifteen hands high, sound in wind and limb and steady as a butcher's table. Do I hear a bid . . . Do I hear a bid for this prime specimen of womanhood . . . *[To LEAMY]* You, sir! You look a decent sort of a man. Do I hear a bid . . . ? She has two medals for making toast and four for making pancakes. She have a gold cup for drinking sour milk and a certificate for snoring.

[Suddenly DANDY stops dead and looks towards the doorway. Enter the BULL McCABE, followed by TADHG, followed by the BIRD O'DONNELL. DANDY'S WIFE gets up immediately and stands near her husband]

Bull: You came, Dandy. Blood is thicker than water.

Dandy: *[Subdued, cautious]* How's the Bull? How are you, Tadhg . . . Bird?

[LEAMY quietly withdraws a little behind grocery counter. MAIMIE comes from behind counter]

Maimie: Your receipt, Dandy.

Dandy: Thanks, Maimie.

Bull: You got the word?

Dandy: Yes, Bull.

Bull: You know there's a man in the village who's here to wrong me?

Dandy: Yes, Bull! Yes!

Bull: Sit down! . . . All of you, sit down! Where's himself, Maimie?

[Enter MICK FLANAGAN]

Mick: Right behind you, Bull. Sorry I'm late.

Bull: *[Generously]* A good man is never late, Mick.

[All sit . . . MICK, the BIRD, TADHG, DANDY and his WIFE. MAIMIE goes forward and sits a little apart independently. BULL sees LEAMY behind the counter]

Bull: What's he doin' up? Shouldn't he be in bed?

Maimie: He's just going.

Bull: No . . . No . . . Let him up. He's no fool. He knows enough. Sit down, boy . . . *out here*, boy.

[LEAMY takes a seat near his mother]

Bull: I'm a fair man and I want nothing but what's mine! I won't be wronged in my own village, in my own country by an imported landgrabber. The sweat I've lost won't be given

for nothing. A total stranger has come and he wants to bury my sweat and blood in concrete. It's ag'in' God an' man an' I was never the person to bow the head when trouble came and no man is goin' to do me out of my natural-born rights. Now this robber comes from nowhere and he's nothing less than a robber . . . And you all know the cure for a robber . . . he must be given a fright and a fright he's goin' to get. But people forgets old friends when there's danger and if this man gets a fright and a bit of a beatin', we'll have the civic guards goin' around askin' questions. Now, you know the kind civic guards is . . . What is friends for, I ask, unless 'tis to pull one another out of hoults. What is neighbours and relations for unless 'tis to 'love ye one another' says the Gospel. So, when the civic guards come with their long noses, all of you will remember that Tadhg and myself were in this pub at the time that robbin' gazebo got his dues . . . We'll give him just enough to teach him a lesson. Now, I'll want a promise, won't I, to show we can trust one another. Dandy, you'll take an oath on the Holy Ghost.

Dandy: Sure, Bull. Sure. And don't worry about the Missus.

Bull: Sound man, Dandy. I knew I could trust you. What about you, Bird?

Bird: OK, but I'm not swearing by the Holy Ghost.

Bull: And what have you got against the Holy Ghost, you little caffler, you?

Bird: 'Tis wrong! 'Tis wrong!

Bull: Did he ever give you a fright?

Bird: A fright?

Bull: Yes, a fright. Any other ghost you'll meet will frighten the life outa you. But the Holy Ghost never gave anyone a fright. Come on, swear!

Bird: Sure, Bull. Sure.

Bull: Mick?

Mick: OK, Bull, but don't overdo it.

Bull: A good fright and no more. Put up a bottle of whiskey for my friends. Maimie . . . Maimie! I'm talkin' to you.

Maimie: And I hear you, Bull.

Bull: Maimie, what do you say?

Maimie: This man has done no harm.

Bull: Not yet . . . not yet . . . but he will.

Maimie: It isn't right to beat a man up. He's alone here.

Bull: He don't belong here.

Maimie: The guards will hear of it.

Bull: Of course they will, but that's the end of it as far as they are concerned, if we all keep our mouths shut.

Maimie: This can lead to nothing but trouble.

Bull: There will be real trouble if you don't swear to keep your trap shut. I know enough about you to cause a right plateful of trouble. Your husband might be blind but the Bull McCabe knows your comings and goings like the back of his hand.

[LEAMY looks curiously at his mother and then gets off stool and tries to run past BULL. BULL stops him]

Bull: And you, boy? You'll be all right, won't you? You don't want your mother to be hurt, do you?

Maimie: Leamy won't say a word.

Bull: Of course he won't. There's men around here would think nothing of puttin' a bomb up ag'in' a public house door. 'Twas done before, the time of the land division. Who's to say what people will do?

[He pats LEAMY and dismisses him]

Maimie: All right! All right! We get the message.

Bull: That's great now. 'Tis a weight off my mind to know that my friends are behind me. Now none of you will leave here after me and Tadhg go and when we come back, 'twill be the same as if we never left. Right, Dandy?

Dandy: Sure thing, Bull.

Bull: Good health. Good health, Maimie.

Bird: Good luck, Bull.

Dandy: Good luck, Bull.

[MICK rises and goes to the back of the bar]

Bull: What I would like now is a song and who better than Dandy.

Bird: Sure Bull.

Bull: Give us 'The Poor Blind Boy', Dandy.

[DANDY commences to sing 'The Poor Blind Boy']

Dandy: *[Sings]* She's left the old field where he played as a baby.
The little white cottage that lies by the sea.
The cradle that rocked him is lonesome and shady
As she thinks of those days that never will be.

[BULL motions to TADHG and they exit quietly. The singing goes on]

They're far from each other, she cries for her
loved one
By night and by morning since ever he died,
She walked through the field while the cold moon
shines down
As she thinks of the fate of the poor blind boy.

[End of Act One]

ACT TWO
Scene 1

[Action takes place at a gateway on the bóithrín near the main Carraigthomond Road. The time is midnight. Two figures are huddled together. They are the BULL McCABE and his son, TADHG. The BULL unwraps a small paper parcel and hands TADHG a sandwich.

Bull: Eat that!

[TADHG accepts sandwich and takes a large bite from it. BULL carefully ties the parcel again and puts it in his pocket]

Tadhg: 'Tis bloody cold! *[Slapping between his armpits]*

Bull: 'Tis April, boy! 'Tis April. Listen and you can hear the first growth of the grass. The first music that was ever heard. That was a good bit o' sun today. A few more days like it and you won't know the face of the field.

Tadhg: D'you think he'll come?

Bull: Hard to say. Hard to say. You're sure you saw no sign of him all day.

Tadhg: Positive.

Bull: He wouldn't have come by the river unknown to you?

Tadhg: No chance! I hid in the shelter since we left the pub this morning and Johnny Sweeney was here till we came from the pub now. All I seen was crows . . . nothin' but crows. What do they be doing' . . . perched in the field all day? They weren't eatin' grass and they weren't diggin' snails. Just perched there, takin' no notice of anythin'. Do they be thinkin' like us?

Bull: I enjoy a crow as much as the next man. The first up in the morning is the crow and the soonest under his quilt.

Tadhg: I seen a few water-rats today.

Bull: Crafty sons o' whores!

Tadhg: They say that if the seed of man fails, the rats will take over the world.

Bull: They're crafty, sure enough. But I could watch crows if
 there was time given for it. I often laughs at crows.

Tadhg: Can they talk to one another? I'd swear they have a lingo
 all of their own.

Bull: Who's to say? Who's to say? Anyway I have something else
 in my head besides the antics of crows.

Tadhg: He'll never come now. 'Tis all hours of the night.

Bull: We'll give it another half-hour and if he doesn't show up,
 we'll go to our beds. God knows I could sleep now, boy.

Tadhg: And my Ma will be wondering.

Bull: Let her wonder. You'll hear no complaint out of her.

Tadhg: Da?

Bull: What?

Tadhg: Why don't yourself and Ma talk?

Bull: Ah, hould your tongue!

Tadhg: Ah, Da, come on! I always told you about my women.

Bull: Your mother is a peculiar woman, son. I won't account for
 her. She's led me a queer life all these years.

Tadhg: How long has it been?

Bull: How long has what been?

Tadhg: Since you spoke to her?

Bull: Eat your sandwich, can't you. You have me addled.

Tadhg: Ah tell us Da.

 [He sits near him]

Bull: *[Rises, pauses and returns to TADHG]* Eighteen years since
 I slept with her or spoke to her.

Tadhg: What was the cause?

Bull: What was the cause but a tinker's pony . . . a hang-gallows
 piebald pony, a runty get of a gluttonous knacker with one
 eye. I was at the fair at Carraigthomond that day and she

gave permission to a tinker's widow to let the pony loose in one of the fields. The land was carryin' fourteen cows an' grass scarce. Fourteen cows, imagine! An' to go throwin' a pony in on top of them! Cripes, Tadhg, a tinker's pony would eat the hair off a child's head!

Tadhg: He would, Da, he would. But what happened between Ma and yourself?

Bull: God blast you! . . . that's what happened. Amn't I after tellin' you?

Tadhg: But after the pony, what happened?

Bull: I was in bed when she told me. I had a share of booze taken. I walloped her more than I meant, maybe. I went out and looked at the pony. He had one eye, a sightful right eye. I shot him through the two eyes, the blind and the good . . . a barrel at a time. It often played on my conscience. If 'twas as ass now, 'twouldn't matter, but a pony is a pony.

Tadhg: And she never spoke to you since?

Bull: Never a word. I tried to talk to her, to come round her. I put in electric light and bought the television. I built that godamned bathroom . . . *for her* . . . all over a tinker's nag, a dirty one-eyed pony. You'd swear he was human.

Tadhg: You had to do it, Da. Carrying fourteen cows. You had to do it.

Bull: Of course, I had to do it but she wouldn't see it that way. You understand all right, Tadhg. You're a sensible fellow who knows the ropes.

Tadhg: A tinker's pony would eat your finger-nails. Didn't you explain to her?

Bull: But you can't explain these things to women. It don't trouble them if the hay is scarce and the fields bald. I seen lonesome nights, Tadhg, lonesome nights. *[Comes suddenly upright]* Whisht! What was that?

[Sounds of a jet]

Tadhg: That's only a jet . . . one of them new ones with the high boomin' sound.

Bull:	An aeroplane, is it?
Tadhg:	That's all it is. I often hear them down here at night. I could tell you the different kinds.
Bull:	*[Good-natured]* An' what do you be doin' down here at night? Eh? Not sayin' your prayers, I'll bet!
Tadhg:	Oh, rambling around, watching out for donkeys.
	[He slaps his armpits and moves around]
Bull:	Women, I suppose! Anyone I know?
Tadhg:	Ah, now, Da!
Bull:	Ah, come on. Tell your oul' Da.
Tadhg:	There's a daughter of Patsy Finnerty's.
Bull:	I seen her. I seen her. A bit red in the legs but a good wedge of a woman. Can she milk?
Tadhg:	As good as ourselves.
Bull:	Can she handle pigs and feed cattle?
Tadhg:	She knows more about them than myself.
Bull:	If she does, she knows a lot.
Tadhg:	She's a man by day but she's a woman at night.
Bull:	And an only daughter into the bargain.
Tadhg:	There's nine acres o' land.
Bull:	I know there's nine. A good nine. Good man yourself. I reared you well. Did you question her?
Tadhg:	I'd say she'd be willing enough. I wouldn't try to rush her, though. She's pampered and headstrong.
Bull:	That will be knocked out of her.
Tadhg:	Sometimes, I drops a hint and she doesn't seem unwilling to listen.
Bull:	Nine acres o' land! Think of it! Keep your napper screwed on and we'll be important people yet, important people, boy!

Tadhg: Why do you think I'm chasing her?

Bull: What's that?

[He pulls TADHG back into the shadows at left. Two girl cyclists pass yahooing and giggling]

Girl 1: Come quickly, Bridie, I'll race you.

Girl 2: Ah, what's your hurry.

Tadhg: *[Crosses back into the light]* That's only a couple o' young ones on bicycles comin' home from the picture in Carraigthomond. Calm yourself, Da. You're very jittery.

Bull: 'Tis cold. I'm used to the bed at this hour.

Tadhg: If he's to come, he'll come.

Bull: If he doesn't come in ten minutes I'm givin' it over. All we'll get here is pneumonia . . . Whisht! . . . that's surely somebody now . . .

[They both listen]

Tadhg: You're right and, whoever it is, he's in a hurry . . . Stay cool now! Stay cool!

[They both withdraw into darkness as steps grow louder. TADHG takes a cap from his pocket and quickly draws it fully over his head. As the approaching party draws nearer, whistling can be heard. Enter the BIRD, out of breath and whistling. He looks around and walks from one end of the stage to the other, calling]

Bird: Bull? . . . Tadhg? . . . Any of you there? Bull, 'tis me, the Bird . . . Tadhg?

[There is no answer and the BIRD is uncomfortable]

Bird: Ah, lads, if you're there, don't be codding me. Come on out. I'm after runnin' from Carraigthomond with a bad heart . . .

[He turns away despondently. At this the BULL and TADHG leap out from their hiding places, shouting and leaping, so that the BIRD rushes from one to another terror-stricken and is forced to sit down. BULL and TADHG laugh uproariously]

Bird: Ye nearly put me off in a weakness. My heart is flutterin' like the engine of a motor-bike.

Bull: That's a terrible pity, Tadhg, isn't it? Bird, if I thought you were a drinkin' man I'd run myself to Carraigthomond to get a glass of brandy for you.

Bird: All right, then . . . be funny . . . and I'll keep my mouth shut . . . about what I know.

[BULL suddenly seizes BIRD by the throat and lifts him to his feet]

Bull: What do you know, ferret? Spit it out or 'twill be spat for you! *[Releasing him]* Come on! Out with it!

Bird: He was in Flanagan's for a drink. I was at the counter talking to Maimie. He said he was going to his lodgings for his coat to have a look at the field.

Bull: So he won't heed my warning.

Bird: Oh, this is the field he fancies all right. It's like love at first sight. Like fallin' for a woman.

Bull: *[Impatiently]* Did you see him?

Bird: He was on the road behind me. That's why I ran. Don't forget who tipped you off, Bull.

Bull: Be sure we won't.

[The BIRD disappears into the darkness]

Tadhg: Listen. *[He listens]* It's bound to be him.

Bull: Who else could it be! . . . Pull back . . . He's comin' near.

[BULL and TADHG withdraw into the shadows. Enter WILLIAM. He wears a light raincoat.
 Hearing a sound, he stiffens and looks about him suspiciously. BULL emerges from the shadows]

Bull: Turn around and go home!

William: Who the hell do you think you are? I have as much right to be here as you.

Bull: I'm telling you now for the last time . . . turn around and go home!

[WILLIAM pauses, undecided. BULL flexes the ashplant in his hand]

William: I'm legally entitled to look at this field.

Bull: I want your solemn oath that you'll leave Carraigthomond first thing in the morning and never set foot here again. Your solemn oath!

William: Don't you threaten me!

Bull: You'll do as your told or your wife won't know you when she sees you again . . . an' I'm not foolin' you, boy!

William: For God's sake, get out of my way.

[He endeavours to advance but the BULL draws a sweeping blow with his ashplant which WILLIAM narrowly avoids]

William: Hey, that's dangerous!

Bull: Your solemn oath! Come on, your solemn oath that you'll quit Carraigthomond and never come back.

William: Come on, have a bit of sense.

[He tries to advance again but the BULL repels him with the stick. Then the BULL drops the stick]

Bull: Come on! Pass us, if you're able!

[Behind him, silently, TADHG emerges from the darkness]

Bull: *[To WILLIAM]* Come on, if you fancy yourself.

William: You won't goad me into assaulting you. A good night's sleep and you might see things a little clearer.

[WILLIAM attempts to pass BULL but TADHG jumps on him from behind, hits him on back of head and knocks him to ground]

Bull: Hold on to him!

[TADHG holds WILLIAM's arms and BULL hits him heavily, skilfully, three or four times. WILLIAM breaks from them,

weakly desperate, but TADHG grabs him by the legs and brings him to the ground again. BULL grabs his stick and beats WILLIAM across the back and head. WILLIAM's screaming dies out. TADHG pulls WILLIAM up as the BULL stops beating him with his stick and gives WILLIAM the knee. WILLIAM falls helplessly. BIRD rushes to TADHG]

Bird: In the name of God, stop! . . . stop! . . . or you'll do for him.

[TADHG throws BIRD aside and gets in a crucial kick at WILLIAM's head]

Bull: Stop it! . . . Stop it! That's enough. We only want to frighten him.

Tadhg: That's what he wanted, wasn't it?

Bull: *[Pulling him away]* Now, if there's any questions about this, where were we tonight? What were we doing? . . . We were in the pub, the three of us. 'Tis ag'in the law but 'tis a sound excuse. Agreed? All to be on the one word. Come on now across the fields. That way we won't be seen . . . Move!

Bird: You're after going too far. I don't like the look of him.

Bull: Get back to the pub!

[The BULL pushes them off and turns to look down at WILLIAM]

Bull: Why couldn't you stay away, you foolish boy? Look at the trouble you drew on yourself, you headstrong foolish boy, with your wife and family depending on you . . . Jesus Christ —

[He kneels and examines WILLIAM. He is suddenly aware that WILLIAM is dead. He looks desperately around, then rises and remains looking down at WILLIAM. He then suddenly kneels and takes WILLIAM's head in his lap and whispers an act of contrition. Looks around him and disappears into the night]

Scene 2

[LEAMY and MAIMIE preparing to leave for Mass]

Maimie:	*[Ad lib]* Put their scarves and hats on, Aoife.
Aoife:	*[Ad lib]* Give me your hand. Off you go, wait for me at the corner.
Leamy:	Has the bishop spoken here before?
Maimie:	I can't remember. Your father would know.
Leamy:	Muddy ?
Maimie:	Yes, love?
Leamy:	Muddy, why are the Bull McCabe and Tadhg and my father and the Sergeant such bullies?
Maimie:	The McCabes are bullies. Your father isn't a real bully and the Sergeant isn't a real bully.
Leamy:	Oh, but they are!
Maimie:	Aoife, take the girls to Mass.
Leamy:	Do you remember the day of the big hurling match, when the Blezzop brothers nearly beat the man to death . . .
Maimie:	Yes.
Leamy:	Well, afterwards, they came into the pub and my father served them with drinks. He started praising them and telling them they were great men and then the small man, Mr Broderick, said to the older brother, 'Out of my way, I wouldn't drink in the same house with the likes of you', and then the Blezzop brothers attacked him and were beating him up. I wanted to run out from behind the counter and help Mr Broderick, but what could I do? So I ran up to the barracks and told the guard on duty. It was two hours later the Sergeant came down.
Maimie:	Leamy!
Leamy:	He asked my father if everything was all right and my father said it was. I was so ashamed. Later on, the guard who was on duty came in and himself and my father were saying that Mr Broderick was an awkward man and that he'd look out for him in the future . . .

Maimie: It's time to go to Mass, love!

Leamy: I was thinking of goin' to the barracks again and telling the Sergeant about the Bull.

Maimie: No . . . not this time! There are hundred of guards, and detectives and the pressure is on for the first time and it's on from the outside. The Bull McCabe won't suffer, Leamy. A few years in jail or a dismissal, but it's you, Leamy . . . it's you who will suffer because, don't you see, it's you who will have done all the work and you'll be a freak for ever more, different from the rest of us.

Leamy: But I want to be different from them, Muddy!

Maimie: Do you love me, Leamy?

Leamy: Yes.

Maimie: Then say no more about this. If you love me and trust me, you will say no more . . . never again until my family is reared and able to look out for themselves.

Leamy: Are you afraid, Mud?

Maimie: I was never afraid once. I feared nothing that walked the face of the earth until my first child was born. A child makes a prisoner of a woman, but Leamy, you're a lovely gaoler . . . come on to Mass . . .

[They start to cross to exit]

Maimie: God, we're a pity, Leamy . . . the whole bunch of us.

Leamy: Except for the small man, that Mr Broderick, and he's gone to England. He was no pity. He was a brave man.

Maimie: Promise me, on your word of honour, no more talk about the killing. No matter who asks you.

Leamy: Yes, Muddy. I promise. I'll always do whatever you tell me.

Maimie: *[Heartbroken]* And what can I tell you, love?

[LEAMY exits. MAIMIE follows into church. They take their place among the parishoners and we cut to the bishop's sermon]

Bishop: 'Do not be afraid of those who kill the body but cannot
kill the soul. But rather be afraid of him who is able to
destroy both body and soul in Hell.'

In the name of the Father and of the Son and of the
Holy Ghost, Amen.

Dearly beloved brethren, these are the words of Christ
Himself. He was speaking about truth. How many of you
would deny Christ? How many of you, like Peter, would
stand up and say: 'I know not the Man!' but you can lie
without saying a word; you can lie without opening your
lips; you can lie by silence.

Five weeks ago in this parish, a man was murdered —
he was brutally beaten to death. For five weeks the police
have investigated and not one single person has come
forward to assist them. Everywhere they turned, they were
met by silence, a silence of the most frightful and diabolical
kind — the silence of the lie. In God's name, I beg you, I
implore you, if any of you knows anything, to come forward
and to speak without fear.

This is a parish in which you understand hunger. But
there are many hungers. There is a hunger for food — a
natural hunger. There is the hunger of the flesh — a natural
understandable hunger. There is a hunger for home, for
love, for children. These things are good — they are good
because they are necessary. But there is also the hunger
for land. And in this parish, you, and your fathers before
you knew what it was to starve because you did not own
your own land — and that has increased; this unappeasable
hunger for land. But how far are you prepared to go to
satisfy this hunger. Are you prepared to go to the point of
robbery? Are you prepared to go to the point of murder?
Are you prepared to kill for land? Was this man killed for
land? Did he give his life's blood for a field? If so, that field
will be a field of blood and it will be paid for in thirty
pieces of silver — the price of Christ's betrayal — and
you, by your silence will share in that betrayal.

Among you there is a murderer! You may even know his
name, you may even have seen him commit this terrible
crime — through your silence, you share his guilt, your
innocent children will grow up under the shadow of this

terrible crime, and you will carry this guilt with you until you face your Maker at the moment of judgement . . .

If you are afraid to go to the police, then come to your priests, or come to me. And if there is one man among you — one man made after Christ's likeness — he will stand up and say: 'There! There he is! There is the murderer!' And that man will have acknowledged Christ before men and Christ will acknowledge him before His Father in Heaven. But if you, by your silence, deny Christ before men, He will disown you in Heaven, and I, as His representative, will have a solemn duty to perform. I will place this parish under interdict and then there will be a silence more terrible than the first. The church bell will be silent: the mass bell will not be heard; the voice of the confessional will be stilled and in your last moment will be the most dreadful silence of all for you will go to face your Maker without the last sacrament on your lips . . . and all because of your silence now. In God's name, I beg of you to speak before it is too late. 'I am the way, says Christ, and the truth. Do not be afraid of those who can kill the body but cannot kill the soul. But rather, be afraid of him who can destroy both body and soul in hell'.

In the name of the Father and of the Son and of the Holy Ghost, Amen.

Scene 3

[Action takes place in the bar of MICK FLANAGAN's public house.

The time is evening, five days later.

Present are MICK FLANAGAN, the BULL McCABE, his son, TADHG, the BIRD O' DONNELL MAGGIE BUTLER and DANDY McCABE.

MICK FLANAGAN stands behind the counter.

The BULL McCABE is in process of counting money which is being accepted by MICK]

Bull: [Counting at table] £310 . . . £320 . . . £330 . . . £340 . . . £350 [To MAGGIE] Now, no one can say you didn't get a fair price. [To MICK] I'll have a receipt for that.

Mick: I have it here for you.

[MICK locates a receipt book and commences to write. The BULL accepts. MICK takes the money and goes to MAGGIE. He puts money in MAGGIE'S lap, while all stand around]

Mick:	Here's your money. 'Tis all there, every penny of £350. It's a fine bundle of notes.
Bull:	Honest got and honest given . . . and now, Mick Flanagan, fill a drink for the house.
	[MICK goes behind bar]
Bird:	A drop of whiskey for me.
Dandy:	A jigger o' rum.
Bull:	Give 'em whatever they want. 'Tisn't everyday that this class o' money makes an appearance.
Bird:	'Tis a high pile o' money. You're blessed with luck in the decent man you met, Mrs Butler.
Maggie:	I have the money taken now and there's no more to be said.
Tadhg:	'Tis a fair exchange, considering.
Maggie:	So you say, but there's many that think that £800 would have been fairer.
Bull:	All gossip . . . nothing but jealous gossip by nosey neighbours who couldn't pay for the site of a sitdown lavatory, not to mind a field. They're great warrants to talk but when it comes to forkin' out the cash, where are they? I am the man with the money — hard-earned and got fair — and I'm not ashamed to say, 'twas the last penny I possessed.
Tadhg:	'Twas every half-penny we owned and we had to flog five heifers to put it together.
Bull:	God, I was lonesome after that little yellow heifer.
Tadhg:	She was a beauty.
Bull:	She was a little queen, boy! The step of this one was like a dropping leaf, Dandy.
Tadhg:	The other four were real ladies too. They were shapely cattle, by God they were. They sold well, Da. You'll have to admit that.
Bull:	And we had to borrow from the bank. We're paupers but isn't it better to be a pauper and have a clean conscience about your debts?

Bird: Oh, by God, that's well spoken.

Dandy: Nicely thrown together. Nicely.

Bull: Isn't it better to have our principles than be millionaires.
 Isn't it, Tadhg?

Tadhg: You're a straight man, Da.

Dandy: None straighter.

Bull: If a man isn't straight, he might as well be dead.

Bird: I admire a straight man.

 [MICK serves them with drinks]

Bull: I grudge no man his property, but a lot of the hangin'
 thieves begrudge me.

Tadhg: 'Tis all jealousy.

Bull: *[Paying for drinks]* Jealousy and spite . . . here's the good
 health to all of us . . .

All: Good luck.

Bull: We have as fine a farm now as the best and maybe more
 to come and a woman with it, eh Tadhg?

Tadhg: 'Twon't be my fault!

Bull: In the course of time, as the man said: in the course of time.

Bird: And a fine heifer she is, too!

Bull: Good legs and a great bussom, God bless the girl!

Bird: Oh, God bless her again.

Dandy: *[Finishing his drink]* Long life to her!

Bull: She's a good milker.

Dandy: For a fact!

Tadhg: A mighty milker!

Bull: With nine acres!

Dandy: Nine!

Bird: Knows her banbh and her pig. Strong, too, and not bad-lookin' when you get used to her.

Bull: She's all that, God bless her.

Mick: Father Murphy . . . !

[Enter SERGEANT LEAHY followed by the priest, FATHER MURPHY]

Bull: *[Seemingly unaware of the new arrivals . . . to MAGGIE]* Mrs Butler, from this out, we'll give you a lift to Mass every Sunday. 'Tis too long a walk for an old woman.

Bird: *[Tips BULL'S chest]* There's a big heart in there: an outsize heart that's too big for this world but God don't miss nothin' an' 'tis wrote down in Heaven in red letters like blood.

Dandy: Well spoke, Bird! Well spoke! Is the names of his friends there?

Bird: *[Sanctimonious, mocking]* Wrote down there, my child, is the names of all the faithful.

Bull: That's a kindly thing to say, Bird. Ah, Father Murphy, if 'tisn't against rules of the Church, could I get a little drop of something for you, Father? Or are the clergy not allowed to take sup in the pubs?

Fr Murphy: No, thank you, Mr McCabe but I will take a bottle of orange if the Sergeant here joins me.

[BIRD nudges TADHG]

Sergeant: I'll have an orange.

Bull: And welcome you are to whatever you like.

[MAIMIE enters]

Maimie: Good morning, Father.

Fr Murphy: Good morning, Mrs Flanagan.

[MICK gives MAIMIE the beck and she goes to left of bar, out of the way]

Bird: Not a bad day outside, Father.

Fr Murphy:	Nice and fresh but a bit chilly.
Bull:	There's a good share of sun now, considering.
Tadhg:	There's good growth.
Bird:	There's amazing growth for the time of year.
Dandy:	I seen buds on every bush on the way in.
Bird:	Buds, imagine, so early!
Tadhg:	Make a good summer!
Bull:	The meadows will be early; early buds, early meadows. How're you for hay, Dandy?
Dandy:	I'll pull through, Bull. I've a share of turnips yet.
Fr Murphy:	Better come to the point. This morning, Sergeant Leahy and I are making house to house calls. Our job is not a pleasant one but alas, 'tis a necessary one.
Bull:	It sounds like a collection.
Sergeant:	It's a collection all right, but this time we're collecting information.
Fr Murphy:	And I hope you'll be more liberal with it than you are with your money.
	[There is an awkward silence which MICK breaks by placing drinks for the newcomers on the counter. BULL pays]
Fr Murphy:	There's nothing to fear. Anything you tell us will be held in the strictest confidence. This is a job which nobody likes but someone must do it or a murderer will be allowed to go free . . . I hope you have no objections, Mick, at our barging in like this.
Mick:	Oh, good God, no, Father! Not at all! Anything I can do, I'll do.
Bull:	Whatever is in our power to be done, will be done, right, Bird? Right, Tadhg? Whatever is in our power by the grace of God.
Sergeant:	Then we'll begin with you, Mrs Butler. And if the rest of you wouldn't mind waiting in the back room for a moment or two, we'll begin right away.

[All look at BULL]

Bull: It can never be said that we stood in the way of the law. Come on, Tadhg! Come on, Bird . . . Dandy!

Mick: This way, gentlemen, you know where to go.

[The four exit]

Fr Murphy: Now, Mrs Butler. This is neither official nor formal. All we want is a little chat and whatever you have to tell us, will go no further.

Maggie: Yes, Father.

Fr Murphy: You heard the Bishop's appeal on Sunday last?

Maggie: Yes, Father.

Fr Murphy: Unfortunately, it seems to have fallen on deaf ears. Now the Sergeant here assures me that the slightest bit of information might easily break the case. Now, Mrs Butler, you live near where the body was found . . . where the murder actually took place. Did you see or hear anything on the night?

[MAGGIE entwines her fingers but does not reply and the priest exchanges looks with the sergeant]

Sergeant: Anything at all, Mrs Butler?

Fr Murphy: Did you hear or see anything? It doesn't matter what. Even a little thing might help the Sergeant.

Maggie: 'Tis me needs the help, God help me.

Sergeant: You met the man didn't you? On the morning of the day he was killed.

Maggie: He was in here all right, that morning. He was a nice man . . . a bit strong-willed.

Fr Murphy: Most men are!

Sergeant: Did anything take place on that day? Was anything said?

Maggie: If there was, I have it forgotten by now. I have no memory at all. 'Twas often a Saturday when I drew my pension, even though I'd want the money.

Sergeant:	Had the dead man an argument with the Bull McCabe?
Maggie:	If he did, I don't remember it. I hate fighting or noise.
Fr Murphy:	Mrs Butler, if you know anything, don't be afraid to tell us. Nothing will happen to you.
Maggie:	I'm a lone widow, living on the side of the road with no one to look after me.
Fr Murphy:	We understand perfectly, Mrs Butler, but place yourself in God's hands and you need have no fear. If you're afraid of anyone, the Sergeant will caution that person and you can be assured of peace and privacy.
Sergeant:	I'll go to the person and tell him that if he so much looks at you sideways, it will be as much as his life is worth.
Maggie:	Oh, no . . . no . . . you mustn't . . . you mustn't . . . You can't.
Sergeant:	So there is a person . . . someone you fear. *[Gently]* Who is it, Mrs Butler? It is your duty to tell us.
Maggie:	I'm an old woman, living alone, and I do be worryin' nights. I have no one with me.
Sergeant:	We all have to worry nights, no matter who we are.
Maggie:	I don't live in the barracks with guards in all the rooms. An old woman . . . a woman drawing her pension that wants to be left alone . . . I never did harm to no one . . . I only ask to be left alone.

[She becomes silent. SERGEANT and PRIEST exchange looks]

Fr Murphy:	*[Kindly]* Very well, Mrs Butler. You can go now.

[MAGGIES rises and goes to exit]

Maggie:	God bless you, Father . . . and pray for me. Pray for me, Father!
Fr Murphy:	God bless you, Mrs Butler. I will pray for you.
Sergeant:	Good day to you, Mrs Butler.

[Exit MAGGIE]

Fr Murphy: *[To SERGEANT]* Sorry, Tom! I was certain that, after the sermon and with the informal approach, you might learn something.

Sergeant: It's not your fault, Father. You can't beat fear and ignorance. You're up against a stone wall.

Fr Murphy: What about Mick Flanagan? Do you want to question him?

Sergeant: Waste of time! Too crafty! He's been questioned ten times already.

Fr Murphy: What about Dandy?

Sergeant: Dandy and the Bull are first cousins. There's no hope there. Dandy would be all right if it weren't for Tadhg and the Bull.

Fr Murphy: The young lad, Leamy?

Sergeant: The mother has him sworn to silence. He'll never renege on her. His lips are stitched forever.

Fr Murphy: He won't easily bear the burden of that legacy in the years ahead of him. *[Pause]* What about Mrs Flanagan herself then? She wasn't questioned before.

Sergeant: Maimie! It might be worth a try, at that.

Fr Murphy: You're a good-looking fellow, Tom. That might hold.

Sergeant: *[Laughs, turns and puts down drink]* With all due respects to you, Father, I'd chance anything if I thought 'twould solve the crime.

Fr Murphy: You needn't go that far! Anyway, two wrongs don't make a right.

Sergeant: You wouldn't say that if you had my job.

[He calls MICK from back room. Enter MICK]

Fr Murphy: If you've no objection, we'd like to talk to your wife.

Mick: I've no objection, if she hasn't. I'll call her. *[Goes to the stairway; calls]* Maimie, you're wanted.

Maimie: *[Offstage; Calls back]* I'll be down in a minute.

Mick: You won't get much out of Maimie, if she's in a sulk.

Sergeant: Strange, isn't it, Mick, the way nobody knows anything about anything?

Mick: Ah, 'tis a terrible state of affairs! Of course it's not our job. My job is auctioneering. Father Murphy says mass and it's up to the guards to catch the murderer.

Sergeant: If the public won't co-operate, there's nothing the guards can do.

Mick: They'll get their wages, no matter what happens.

Fr Murphy: But the public, Mick. They've . . .

Mick: Ah, come off it now, Father! The public aren't getting paid. 'Tis the other way around. We're payin' the guards and when they can't do their job they blame it on the public. No reflections on you, Sergeant. God knows, you're a sound man at your job.

 [Enter MAIMIE]

Maimie: All right! I confess everything! I killed him! I've said goodbye to the kids. *[Raises her hands over her head]* Take me, Sergeant.

Fr Murphy: This isn't a laughing matter, Mrs Flanagan. A man has been murdered, a murder isn't a joke.

Maimie: All right! So a man has been murdered! What's it to me? I've nine kids to look after. Look at the state of me from cooking and scrubbing and scraping but, thank God, I'm off on my annual holidays soon.

Sergeant: What annual holidays?

Maimie: I'm pregnant again, so I'll have a holiday with the new baby; the only one we'll ever have together.

Mick: Ah, now, Maimie, not in front of Fr Murphy.

Maimie: You're the fault of it, goddam you! Just look at him. You'd think butter wouldn't melt in his mouth.

Mick: Ah, Maimie . . .

Maimie: I'll be carrying all through the summer. All over you! . . . My head is gone queer from it! . . . what was it you wanted me for, Father?

Fr Murphy: It's in connection with the murder.

Maimie:	He did it . . . take him away! I'd swear him to the gallows if I thought I could spend a year without having a baby.
Sergeant:	Seriously, Maimie.
Maimie:	I'm serious, Sergeant. I'm more serious than you.
Sergeant:	I think maybe you can help us. You may be the one who can break this case.
Maimie:	Me! How can I help you?
Sergeant:	Well, you met the dead man. He was here the day of the auction. Did you hear or see anything that might help us?
Maimie:	Hear or see anything! What in the name of God are you talking about?
Sergeant:	The Bull McCabe was here that day?
Maimie:	He was.
Sergeant:	Didn't he have an argument with the dead man?
Maimie:	You can't argue with a dead man!
Sergeant:	Don't mock this dead man. He was murdered!
Maimie:	And don't talk to me, you yahoo from God-knows-where!
Fr Murphy:	You're sure nothing was said?
Maimie:	I don't remember it. They seemed quite friendly to me.
Sergeant:	Quite friendly?
Maimie:	No, not quite friendly! I should have said fairly friendly or a kind of friendly. What kind of friendly would you like? Would reasonably friendly do, or would it convict me?
Sergeant:	*[Anger]* For God's sake, Maimie . . . was anything said?
Maimie:	Yes . . . but don't ask me what was said. A woman has a head like a sieve and a woman expecting for the tenth time should have her head examined! How well they wouldn't murder me! No such luck! I'll have to stay alive and look at thicks like you climbing on other people's backs because you have authority.
Fr Murphy:	You have nothing to tell us?

Maimie:	What do you think I am? A bloody schoolgirl, is it?
Sergeant:	You were here the night of the murder?
Maimie:	I'm always here! Always! Now, for Christ's sake, get out of here and let me alone till I get the dinner.

[Exit MAIMIE]

Mick:	She's in the sulks today. 'Tis me will pay for it now for the next seven or eight months. A pregnant woman is worse than a bloody volcano.
Sergeant:	You told the investigators that the Bull and his son were here the night of the murder.
Mick:	And so they were!
Sergeant:	You're sure of that?
Mick:	God Almighty, didn't I tell it to four different detectives with notebooks. All taken down different like the Four Gospels, but all on the one word when the man is crucified, whoever he is.
Sergeant:	And the Bird, was he here too?
Mick:	You know damn well, he was! What's the point in repeating these questions?
Fr Murphy:	Now, Mick, the Sergeant has his job to do. There's nothing personal.
Mick:	Yes, but goddamit I've told him the same thing a hundred times and he still tries to make me out a liar. He'll go too far. He wouldn't be the first Sergeant to be transferred. I always voted right.
Sergeant:	I'm well aware of how you vote. Will you tell the Bird I want him.
Mick:	Very well. But hurry it up. What will the neighbours think, the Sergeant and the priest here all morning? 'Tis how they'll think I'm the murderer.
Sergeant:	Don't worry, Mick. Everybody knows that it wasn't you, because everybody knows that it was another man . . . maybe two men.

Mick: 'Tis your job to find out.

[Exit MICK]

Sergeant: I won't be transferred . . . 'twould be too much to expect.

[Enter the BIRD]

Bird: More questions?

Sergeant: You don't have to answer.

Bird: I'll answer. I'll co-operate. That's one thing about the Bird — co-operation. None of us can get along without it. If there was more co-operation the world would be an easier place. Am I right, Father?

Fr Murphy: The Sergeant wants to talk to you.

Bird: You can depend on the Bird. Now, Sergeant, what can I do for you?

Sergeant: The night of the murder . . .

Bird: Yes, of course . . .

Sergeant: You say you were here at the time with the Bull McCabe and his son . . . in their company.

Bird: That is correct. Exactly what was spoken. Dead right there for a start, anyway, and a big change from the plain-clothes.

Sergeant: As far as I remember, Bird, the Bull was never a friend of yours. How come, then, that you spent a night drinking together?

Bird: I'll forgive any man, Sergeant . . . any man. Let bygones be bygones is my policy.

Sergeant: You're sure you weren't anywhere near Maggie Butler's field over the river that night?

Bird: Neither near it nor within it. Arrived here at Flanagan's pub, time . . . 9.25 pm. Joined forces with my two friends. Did remain with associates on the premises till 2.45 am. Arrived home at 3 am sharp. Fried sausages one pound and one half and one ring of pudding white. Made pot of tea for self, Bull McCabe and son, Tadhg. Did say goodnight

to same who departed for home. Was in bed at 3.45 pm and that's my story, long enough, as told to seven different detectives on seven different occasions and as told to yourself and His Reverence right now on this day of our Lord, 1965, Amen.

Sergeant: And very nicely put together, too! Do you have any ideas about who might have killed this man?

Bird: I am of the opinion the crime was committed by tinkers or if 'twasn't tinkers 'twas done by persons unknown. They are the biggest blackguards of all, those persons unknown. You see they does everything unknown to people so no one knows who they are. Definitely, persons unknown.

Sergeant: I see . . . and have you any proof of this?

Bird: It's only my opinion, Sergeant . . . and it was only my opinion that you wanted. Opinions is not evidence, Father!

Sergeant: I'll watch you night and day from this on, you dirty, little sewer-rat. I'll haunt you, because I know as well as you do who committed the murder . . . And I think you were present when it happened.

Bird: If I was a big noise you wouldn't haunt me, Sergeant. You know who to haunt, all right!

Sergeant: It is my opinion, Bird, that you witnessed this murder and that your silence was bought for a few pounds. How much did you get? £5 . . . £10 . . . £20? Look, Bird, I'll guarantee you £500, £500 in hard cash, if you'll give me a hint. No one will know where the information came from.

Bird: If I took that £500, you'd be trying to solve a second murder, and you'd be no nearer than you are to solving this one.

Fr Murphy: Who are you afraid of, Bird?

Sergeant: The Bull, is it? Or Tadhg?

Fr Murphy: Or both?

Sergeant: £500.

Bird: 'Twould just about pay the expenses of my funeral.

Sergeant: It wouldn't be your funeral!

Bird: Are you guaranteeing that as well? I have to live, and what's more, I have to live in Carraigthomond, murder or no bloody murder.

[BIRD turns to exit]

Fr Murphy: Bird!

[BIRD stops]

Sergeant: Let him go!

[BIRD exits]

Sergeant: McCabe and his son killed this man. You know, I know and the whole village knows. Nobody cares and the terrible thing is that nobody ever will care.

[Enter the BULL, TADHG and DANDY]

Bull: How long more are you going to keep us stuck back here like prisoners of war?

Fr Murphy: We're sorry, Mr McCabe. The rotation was accidental.

Bull: Ah, that's all right, Father. We understand.

Sergeant: Bull . . . Bull . . . Will you answer me one question?

Bull: If I'm able.

Sergeant: Which of you killed him?

Bull: Well, now, I'm damn downright glad you asked me that because I have a fair idea. *[Becomes confidential]* The wits was often frightened out of me, too, many a night, not knowing the minute a band of tinkers would break out from a bush and hammer my brains out. Try the camp of the Gorleys and if it isn't one of the Gorleys, try the McLaffertys, and if it 'tisn't one of them, 'tis sure to be one of the Mulligans. Don't they kill one another, not to mind killing a Christian?

Tadhg: God, yes, Da! Yes! They're a terror!

Bull: Or whose to say 'twasn't an ass or a stallion. I heard of an ass kicking an oul' woman to death up the country some-where. My wife was run out of the haggard by two Spanish

	mares of a day — two crotchety bitches who'd as soon eat you as kick you. And ask Dandy there, Dandy's wife was chased by a piebald ass, a stallion. Isn't that right, Dandy?
Dandy:	She lost her voice for a week from the fright she got. And she woke with nightmares nine nights running.
Sergeant:	Very touching! Thanks for the help, Dandy, You can go now.
Bull:	Good man, Dandy, mind yourself. And do you know another thing . . . and this might be the answer. Ask the ordinary man and that's where's the answer.
Sergeant:	Yes?
Bull:	What took him down there at that time of the night? What would take you down there, Tadhg?
Tadhg:	A woman is the only thing that would carry me.
Bull:	And a woman it was, believe me! Isn't all the murders over women? 'Twas surely a woman.
Sergeant:	You think so?
Bull:	Some doxy with no grazing of her own. What brought him without his wife, eh? Another woman was the draw . . . maybe a married woman, in pardon to you, Father. There they were, hobnobbing and cronawning under a bush when the woman's husband arrived. Can you blame the poor man, Father? In all fairity can you blame him for murderin' a home-wrecker. Don't be too hard on him, Sergeant, when you catch him.
Sergeant:	It wasn't tinkers, Bull. It wasn't a donkey and it wasn't a jealous husband. Now, was it?
Bull:	*[Passionately]* And, by God, it wasn't Bull McCabe and it wasn't Tadhg and Tadhg and me are sick of your dirty, informer's tactics. You've been after us now, since the donkey was kilt. We're watching your shifty peeler's questions. The two of you there have the power behind you. Why isn't it some other man you picked, Sergeant, to go searching with you? Like the labourer or the servant boy? Why isn't it a ploughman or the Council worker? No . . . you picked one of the gang. If 'twasn't the priest,

'twould be the doctor or the school-master or the shop-keeper. You have the law well sewn up, all of you . . . all nice and tidy to yourselves.

Fr Murphy: *[Hurt]* That's not true! You're deliberately twisting . . .

Bull: Christ had no guard's uniform and He had no white collar around His neck. But He picked a gang of small farmers and poachers. They had their cross like all poor people, and that held them together. If a poor man does something wrong he gets a guard's baton on the poll and he's lugged up the barracks. But, if 'tis the doctor or the schoolmaster or the lawman, they say, 'tis tough on them but there's a way out and the law is law no more.

Sergeant: See here now . . .

Fr Murphy: Let him go on!

Bull: I seen an ould priest last year, as called to our house outside. He sat down near me and spoke to Tadhg and me about hard luck, about dead-born calves and the cripples you meet among dropped calves. He ate with us and he got sick after it . . . fat mate but he ate it and by God, he had a shine of us and said he wished he was like us. I gave him a pound and Tadhg gave him seven and a tanner and if he wanted to stay with us for a year, we'd have kept him. But I won't pay you no Christmas dues, Father . . . not no more . . . and there's no law against that . . . Were we fond of him, Tadhg, of that ould priest?

Tadhg: We were, Da, we were. He was one of our own.

Mick: I'll have to ask you to go now, Father. What will the village think if ye don't leave? We have a family to think of.

Sergeant: You're a cleverer man than I took you for, Bull!

Bull: The likes of us that's ignorant has to be clever.

Sergeant: Did you see the dead man's widow at the funeral, Bull?

Bull: I saw her . . . wasn't Tadhg and myself the first to sympathise?

Fr Murphy: We can't beat the public, Tom.

Sergeant: It's what the public wants.

Fr Murphy: But they never really get what they want.

Bull: Don't we now. You're wrong there, Father. You have your collar and the Sergeant, his uniform. I have my fields and Tadhg, *[To TADHG]* remember this. There's two laws. There's a law for them that's priests and doctors and lawmen. But there's no law for us. The man with the law behind him is the law . . . and it don't change and it never will.

Fr Murphy: Do you ever think of God . . . any of you?

Bull: He's the man I says my prayers to, and I argues with Him sometimes.

Fr Murphy: About what?

Bull: Same as you, 'cos I'm the same kind of creature as you.

Fr Murphy: The Sergeant asked you if you spoke with the widow and you said you did. Did you feel pity for her?

Bull: I'm like you. I can't support her 'cos I'm married myself and you'll hardly throw off the collar and marry her . . . When you'll be gone, Father, to be a Canon somewhere and the Sergeant gets a wallet of notes and is going to be a Superintendant, Tadhg's children will be milking cows and keeping donkeys away from our ditches. That's what we have to think about and if there's no grass, that's the end of me and mine.

Fr Murphy: God will ask you questions about this murder one day.

Bull: And I'll ask God questions! There's a lot of questions I'd like to ask God. Why does God put so much misfortune in the world? Why did God make me one way and you another?

Sergeant: Let's go, Father, before I throw up!

Fr Murphy: You'll face the dead man's widow some day, McCabe . . . not here, but in another place.

Bull: Indeed I won't, Father, because she'll have her own facing to do with another man by her side.

[Exit FR MURPHY and SERGEANT]

Bull: *[Louder . . . after them]* No, I won't face her because
I seen her and she's a pretty bit and the grass won't be
green over his grave when she'll take another man . . .
A dead man is no good to anyone. That's the way of the
world. The grass won't be green over his grave when he'll
be forgot by all . . . forgot by all except me! *[To MICK]*
There's your other twenty. C'mon Tadhg.

*[BULL pauses a moment. Then gathering himself, he throws
back the remainder of his drink and leaves the pub. MICK
gives the counter a wipe and returns upstairs. Silence.*

*The half-door of the cubbyhole we saw in the first act
swings open, revealing LEAMY. He has been there
throughout the scene. He climbs out and stands centre
stage. We feel that he is in the grip of torturous indecision,
but finally he turns reluctantly to the table and begins
clearing the drinks away]*

[The End]

MORE MERCIER BESTSELLERS

THE YEAR OF THE HIKER

John B. Keane

The Hiker is the much hated father who deserted his wife and family and whose return is awaited with fear.

THE CHASTITUTE

John B. Keane

'A Chastitute is a person without holy orders who has never lain down with a woman.' This is the definition given by John B. Keane, who in this amusing play holds up some 'sacred cows' to ridicule.

MOLL

John B. Keane

An hilariously funny comedy by Ireland's most influential and prolific dramatist.

THE MAN FROM CLARE

John B. Keane

The personal tragedy of an aging athlete who finds he no longer has the physical strength to maintain his position as captain of the team or his reputation as the best footballer in Clare.

THE BUDS OF BALLYBUNION

John B. Keane

The Buds come to the seaside at Ballybunion for their yearly break. (Bud is an abbreviation of the Irish word, *bodaire*, meaning a rough country person.)

THE CHANGE IN MAME FADDEN

John B. Keane

A powerful drama depicting a woman facing the change of life, and how her family fail to understand the turmoil she is experiencing.

IRISH SHORT STORIES

John B. Keane

There are more shades to John B. Keane's humour than there are colours in the rainbow. Wit, pathos, compassion, shrewdness and a glorious sense of fun and roguery are seen in this book. This fascinating exploration of the striking yet intangible Irish characteristics show us Keane's sensitivity and deep understanding of everyday life in a rural community.

John B. Keane draws our attention to both the comic and tragic effects of small town gossip in 'The Hanging' — a tale of accusation by silence in a small village — and 'The Change'— a carefully etched comment on a town waking up to undiscovered sexuality. With his natural sense of character, a gift for observing and capturing traits he gives us an hilarious, mischievous and accurate portrait of the balance of justice in 'You're on Next Sunday' and 'A Tale of Two Furs'. We see his uncommon gift for creating characters and atmosphere in 'Death be not Proud' and 'The Fort Field'.

Keane's magic, authentic language and recurrent humour weave their spells over the reader making this exciting book a 'must' for all Keane fans.

MORE IRISH SHORT STORIES

John B. Keane

In this excellent collection of *More Irish Short Stories* John B. Keane is as entertaining as ever with his humorous insights into the lives of his fellow countrymen. Few will be able to resist a chuckle at the innocence of bachelor Willie Ramley seeking a 'Guaranteed Pure' bride in Ireland; the preoccupations of the corpse dresser Dousie O'Dea who felt that 'her life's work was complete. For one man she had brought the dead to life. For this, in itself, she would be remembered beyond the grave'; at the concern of Timmy Binn and his friends for 'the custom to exaust every other topic before asking the reason behind any visit': the intriguing birth of Fred Rimble and 'the man who killed the best friend'.

LETTERS OF A MATCHMAKER
John B. Keane

The letters of a country matchmaker faithfully recorded by John B. Keane, whose knowledge of matchmaking is second to none.

In these letters is revealed the unquenchable, insatiable longing that smoulders unseen under the mute, impassive faces of our bachelor brethern.

Comparisons may be odious but readers will find it fascinating to contrast the Irish matchmaking system with that of the 'Cumangettum Love Parlour' in Philadelphia. They will meet many unique characters from the Judas Jennies of New York to Fionnula Crust of Coomasahara who buried two giant-sized, sexless husbands but eventually found happiness with a pint-sized jockey from North Cork

LETTERS OF A SUCCESSFUL T.D.
John B. Keane

A humorous peep at the correspondence of Tull MacAdoo, a rural Irish parliamentary backbencher. Keane's eyes have fastened on the human weaknesses of a man who secured power through the ballot box, and uses it to ensure the comfort of his family and friends.

LETTERS OF AN IRISH PARISH PRIEST

John B. Keane

There is laughter on every page of the correspondence
between a country parish priest and his nephew who
is studying for the priesthood. Fr O'Mora has been
referred to by one of his parishioners as one who 'is
suffering from an overdose of racial memory
agravated by religious bigotry'. Keane's humour is
neatlt pointed, racy of the soil and never forced. This
book gives a picture of a way of life which though in
great part is vanishing is still familiar to many of our
countrymen who still believe 'that priests could turn
them into goats'. *Letters of an Irish Parish Priest*
brings out all the humour and pathos of Irish life.

LETTERS OF A LOVE-HUNGRY FARMER

John B. Keane

John B. Keane has introduced a new word into the
English language – *chastitute*. This is the story of a
chastitute, i.e. a man who has never lain with a
woman for reasons which are fully disclosed in this
book.

THE GENTLE ART OF MATCHMAKING AND OTHER IMPORTANT THINGS

John B. Keane

This book offers a feast of Keane. The title essay reminds us that while some marriages are proverbially made in Heaven others have been made in the back parlour of a celebrated pub in Listowel – and none the worse for that!

But John B. Keane has other interests besides matchmaking and these essays mirror many moods and attitudes. Who could ignore Keane on Potato-Cakes? Keane on Skinless Sausages, on Half-Doors? Is there a husband alive who will not recognise some one near and dear to him when he reads, with a mixture of affection and horror, the essay on 'Female Painters'? And, more seriously, there are other essays that reflect this writer's deep love of tradition; his nostalgic re-creation of an Irish way of life that is gone forever. Admirers of Keane's plays will recognise in 'Sideways Talkers' and 'The Spirit of Christmas' the ruthless economy of a dramatist who can conjure up a character and a situation in a few lines.